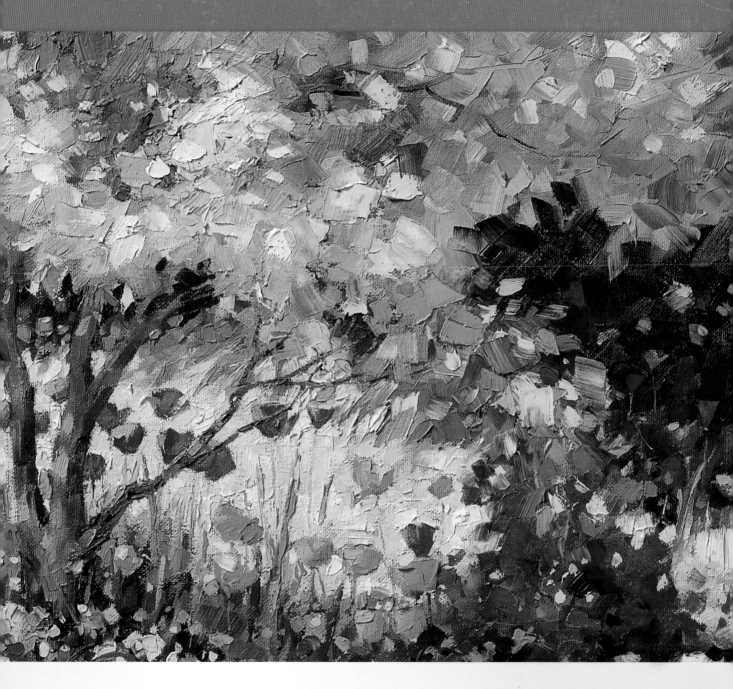

BRILLIANT COLOR: Painting Vibrant Outdoor Scenes

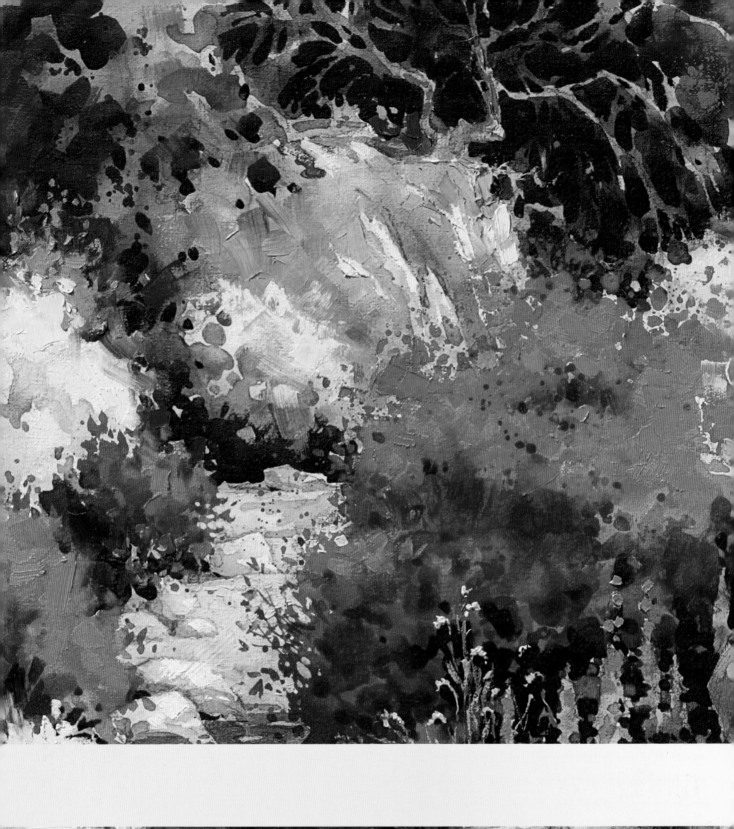
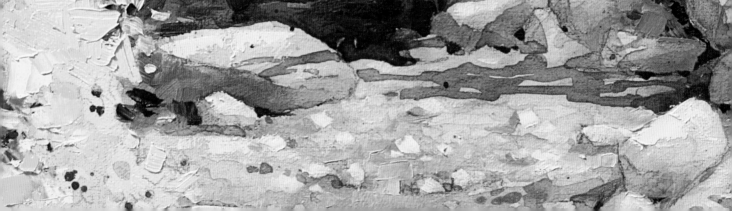

Julie Gilbert Pollard

BRILLIANT COLOR: Painting Vibrant Outdoor Scenes

NORTH LIGHT BOOKS
Cincinnati, Ohio
www.artistsnetwork.com

fw Other fine North Light Books are available from your local bookstore, art
F+W PUBLICATIONS, INC. supply store, online supplier or visit our website at www.fwmedia.com.

PB: 13 12 11 10 09 5 4 3 2 1
HC: 13 12 11 10 09 5 4 3 2 1

Distributed in Canada by Fraser Direct
100 Armstrong Avenue
Georgetown, ON, Canada L7G 5S4
Tel: (905) 877-4411

Distributed in the U.K. and Europe by David & Charles
Brunel House, Newton Abbot, Devon, TQ12 4PU, England
Tel: (+44) 1626 323200, Fax: (+44) 1626 323319
Email: postmaster@davidandcharles.co.uk

Distributed in Australia by Capricorn Link
P.O. Box 704, S. Windsor NSW, 2756 Australia
Tel: (02) 4577-3555

Library of Congress Cataloging-in-Publication Data

Pollard, Julie Gilbert
 Brilliant color : painting vibrant outdoor scenes /
Julie Gilbert Pollard. -- 1st ed.
 p. cm
 Includes index.
 ISBN 978-1-60061-474-3 (hardcover : alk. paper)
 ISBN 978-1-60061-058-5 (pbk. : alk. paper)
 1. Landscape painting--Technique. I. Title.
 ND1342.P65 2009
 751.45'436--dc22
 2008029593

Edited by Kathy Kipp
Design and layout by Clare Finney
Production coordinated by Matthew Wagner
Finished paintings photographed by Melanie Warner

METRIC CONVERSION CHART

To convert	to	multiply by
Inches	Centimeters	2.54
Centimeters	Inches	0.4
Feet	Centimeters	30.5
Centimeters	Feet	0.03
Yards	Meters	0.9
Meters	Yards	1.1

About the Author

Phoenix artist, Julie Gilbert Pollard, paints in oils and watercolor in a fluid, painterly manner. Her painting style, while representational, is colored with her own personal concept of reality. "The eye may see as a camera sees, but the mind's eye sees an altered, imagined image, what it wants and hopes to see. It's that illusive image, uniquely mine, along with a heightened sense of 'realness' that I try to express in my paintings. This world of ours is often a frightening and mysterious place, but it is filled with scenes and subjects that excite my eye and imagination! The magical allure of the natural world, and my reverence for it, compel me to attempt to capture its essence on canvas or paper."

Julie has given instruction in watercolor and oil painting since 1985 and currently conducts classes and workshops in the greater Phoenix area at The Scottsdale Artists' School, Shemer Art Center, West Valley Art Museum and Cynthia's Art Asylum, as well as occasional remote location workshops.

A frequent award winner, Julie's oils and watercolors have hung in numerous juried and gallery exhibits. Her work is included in many private and corporate collections and is currently represented by Artistic Viewpoints Gallery and Studio in Gardnerville, Nevada; Esprit Decor Gallery in Phoenix, Arizona and Windrush Gallery in Sedona, Arizona.

Dedication

To my dearly departed and much loved parents, Frieda and Wayland Gilbert, who always made sure my sister and I had materials with which to create, even when times were hard and money tight.

Acknowledgements

I would like to acknowledge the following people:

My late and very dear husband, John Pollard, who encouraged my dreams and would love to have seen this book.

My wonderful and always-supportive husband, Bob Cox, who even brings me meals when I'm chained to my easel—thank you, love.

My beautiful daughters, Tammy Garcia and Traci Arellano, of whom I am so very and justifiably proud—and their beautiful families. In fact, my entire family—I love you all dearly.

Special thanks to my grandson, Nicholas Hampton, my computer guru, for ushering me into the digital age! I don't know how I could have completed this project without the technology and support he has provided me.

My editor, Kathy Kipp. Thanks so much for your friendly support, your lively and fun correspondence and above all, your expertise.

I so appreciate the support of loved ones, friends and students, gallery owners and personnel, collectors, editors, publishers, art school personnel and all art lovers everywhere! It's a great privilege and challenge to be a landscape painter and we of that persuasion need all the encouragement we can get!

I am especially grateful in a very personal sense for the "green movement" that has finally gained more widespread popularity and compliance. I am so in love with the wonders of this planet. My fervent desire is that its beauty be saved for future generations.

Contents

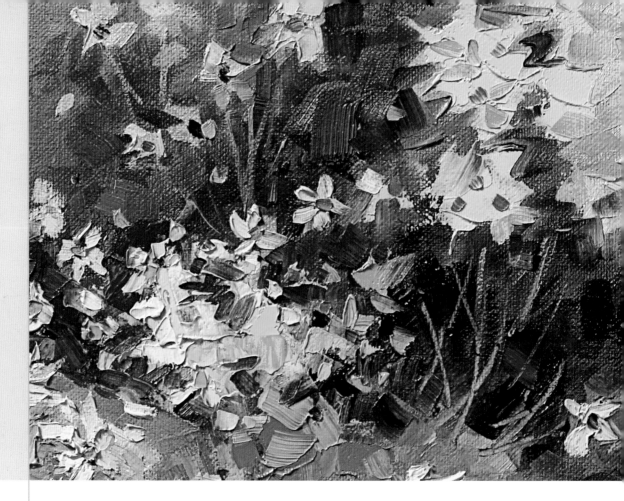

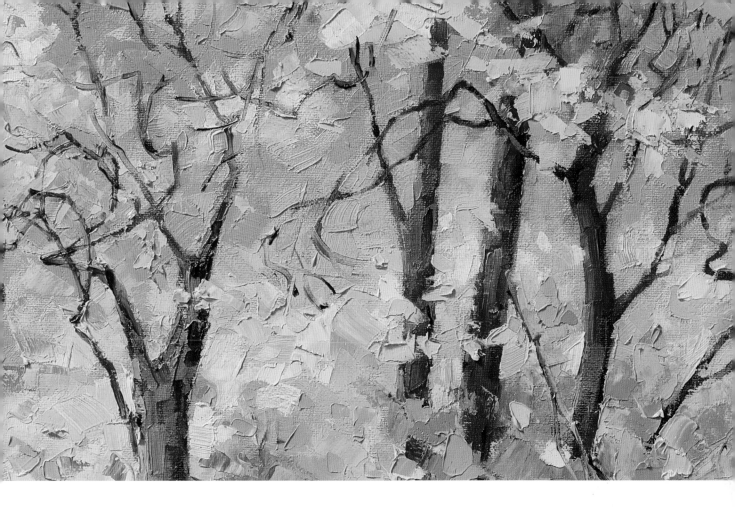

LET'S PAINT! 10 DEMONSTRATIONS IN BRILLIANT COLOR

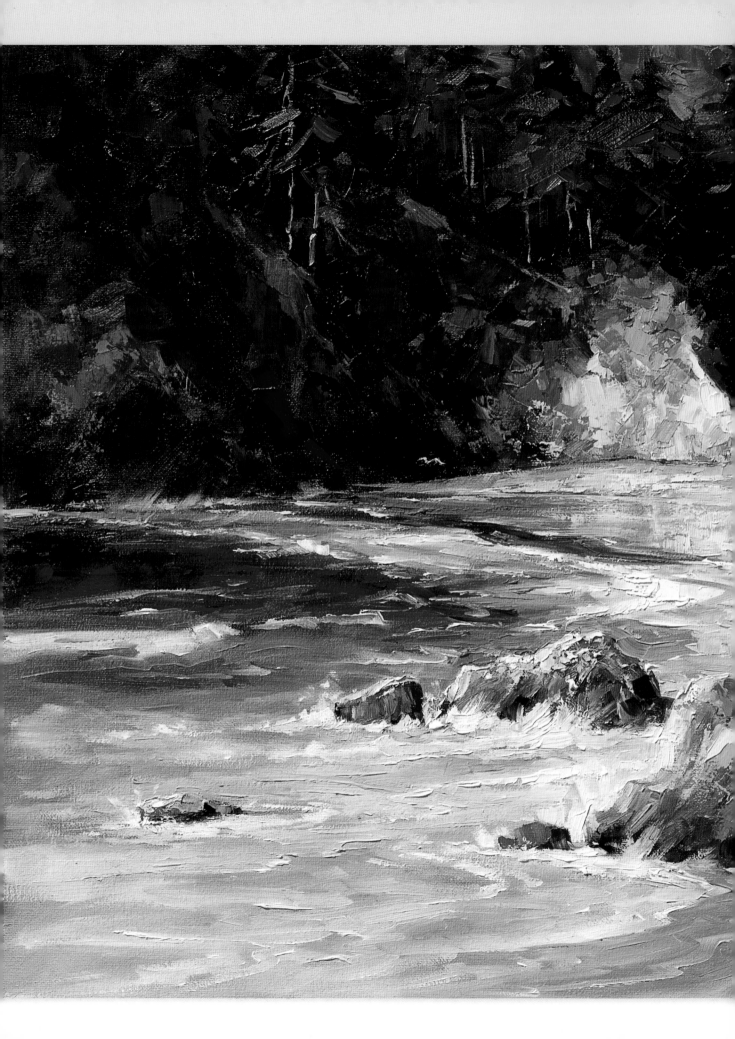

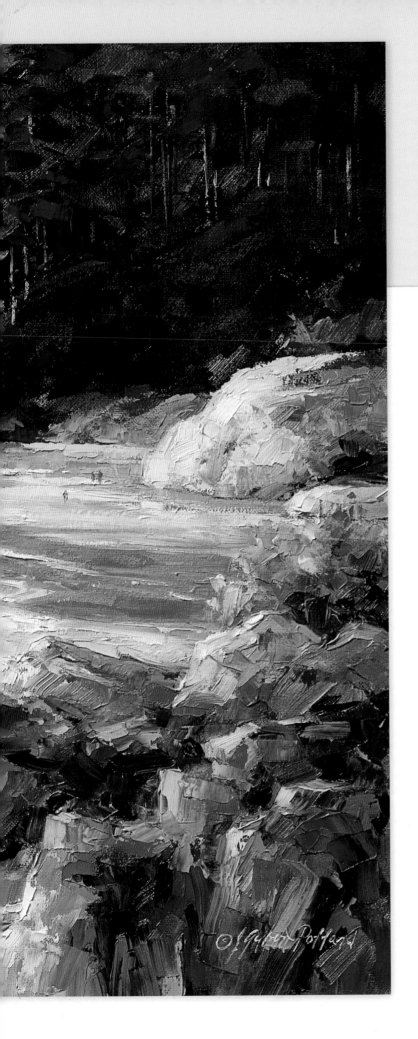

Introduction

When I first began to paint, I tried diligently to match skin tones, foliage and rock colors, etc. with what I thought I saw in nature. Somewhere along the line, though, I realized that—for me—that was boring. As I gazed at and studied the many paintings that really excited me, I found in those wonderful paintings that pushed the envelope of color, the permission to push beyond my own color preconceptions. In my studies, I was also taught that value (dark and light) is of paramount importance, that if you get the values correct, you can use some pretty wild colors and still produce a realistic-looking painting.

In my current work, using color arbitrarily—color as value *and* color simply for the pure pleasure of it—is a theme running throughout my paintings and possibly my main personal color concept and practice. For example, if I want to put purple or pink, or whatever, in foliage which my left brain tells me is green, I make it work by using the correct value, then putting whatever color I like where I like. This satisfies my desire to paint representational scenes, yet give them some unexpected color excitement.

As you discover your own taste and painterly voice, you must push yourself in many directions until you find a set of techniques and ideas that work for you. Above all, enjoy the journey!

PAINTS, BRUSHES AND SUPPLIES

Acrylics

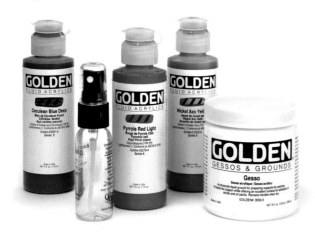

which is opaque. This works for me. I must stress that this is my way, not—definitely not—*the* way! Please don't be concerned if your acrylic handling is more opaque—that is a perfectly legitimate way to use the medium. You might even find you want to try medium- or heavy-bodied acrylics, metallics or some of the many acrylic "grounds" that are available. Experiment—have a blast!

For the paintings in this book, I'm using Golden Fluid Acrylics. They are professional grade paints that come in bottles and are available at your local art supply store. The one exception is, I use white gesso instead of white acrylic paint. The Master Acrylic Color Chart on page 14 shows all the colors we'll be using in the demonstrations.

Paints The acrylic medium is an amazingly versatile medium. The manner in which we will be using acrylics in this book merely scratches the surface of the possibilities. My personal favorite use of the medium is to use it in a fashion similar to the way watercolor is used—that is, transparently—occasionally using it a bit more like gouache,

Brushes For painting with acrylics, I use brushes by Winsor & Newton, Connoisseur, and Royal & Langnickel in the following sizes:

- 1/2-inch (13mm) nylon aquarelle flat (Connoisseur)
- 3/4-inch (19mm) nylon aquarelle flat (Winsor & Newton)

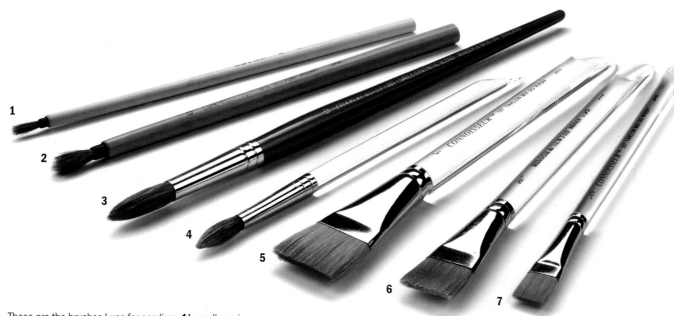

These are the brushes I use for acrylics: **1)** small sumi brush; **2)** medium sumi brush; **3)** no. 12 sable/synthetic blend round; **4)** no. 8 natural hair round; **5)** 1-inch (25mm) nylon aquarelle flat; **6)** 3/4-inch (19mm) nylon aquarelle flat; and **7)** 1/2-inch (13mm) nylon aquarelle flat.

MASTER COLOR CHART: OILS

Holbein Duo Aqua Water-Mixable Oils

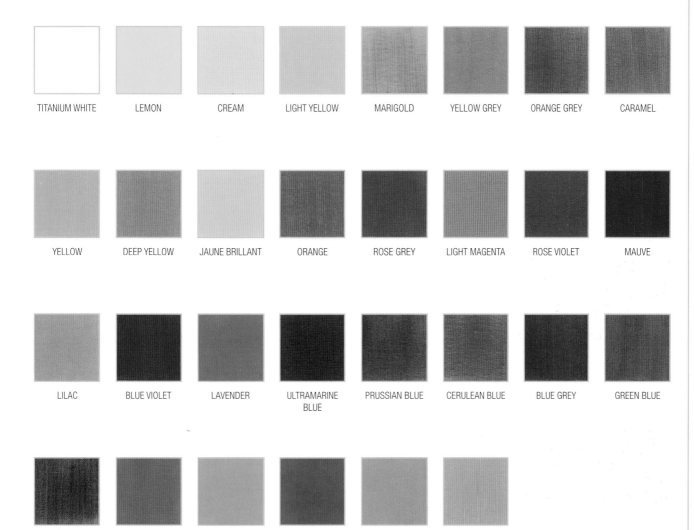

TITANIUM WHITE	LEMON	CREAM	LIGHT YELLOW	MARIGOLD	YELLOW GREY	ORANGE GREY	CARAMEL
YELLOW	DEEP YELLOW	JAUNE BRILLANT	ORANGE	ROSE GREY	LIGHT MAGENTA	ROSE VIOLET	MAUVE
LILAC	BLUE VIOLET	LAVENDER	ULTRAMARINE BLUE	PRUSSIAN BLUE	CERULEAN BLUE	BLUE GREY	GREEN BLUE
PRUSSIAN GREEN	COBALT GREEN	ICE GREEN	GREEN GREY	YELLOW GREEN	LEAF GREEN		

Winsor & Newton

CADMIUM RED HUE (ARTISAN WATER MIXABLE OIL COLOUR)	PURPLE LAKE (GRIFFIN ALKYD OIL)	PERMANENT ROSE (ARTISAN WATER MIXABLE OIL COLOUR)

Acrylic Palette

It's time to set up your palettes. We will start with the acrylics palette. You must remember that acrylics dry very fast. This is why I use a Masterson "wet palette." The Masterson palettes come in three sizes and each can be used for either oil or acrylic. I use the medium size, 10 x 14½ inches (25.4 x 35.6 cm) for acrylics. The palette comes with a thin sponge material and several sheets of palette paper. Before squeezing out the paint, the sponge and a sheet of palette paper are both saturated with water. The paint is then squeezed out onto the paper. If you mist the paint frequently and cover the palette with its lid when not in use, your paint will stay moist for many days. If you tend to keep your acrylic palette for too long a time, the paint may form mold due to the constantly moist environment. If it does, just throw out that sheet of palette paper and start fresh. The sponge will be stained with paint, but you can continue to use it for many painting sessions, though you might want to rinse it out between times.

Since we will be using the acrylics much like watercolor, squeeze out only a small amount at a time—a dollop roughly the size of a pea. You can always squeeze out more if you need it.

I recommend that you use a system for the order in which you place your colors. You might find a system that works better for you than my system, but do use a system of some sort rather than putting your colors out just any old place. I place my colors in the same order as in the color wheel shown on page 18, where yellow is at the left and the colors proceed clockwise around the wheel. There are several reasons why I believe strongly in a system and why I use this particular one:

- it will help you to learn about the colors you use because they will always be in the same place
- it will help you to learn color mixing
- you will always know where your colors are without having to search
- it's part of developing good work habits—the logic of using a system that makes sense to you is an idea that fits neatly into the organization of your painting process.

Maintaining consistency with this system will be even more important with oils since we will be using so many more oil colors than acrylics.

Furthermore, arrange your colors around the perimeter of the palette—don't just place them willy-nilly. For acrylics, you will need that center area for mixing color. For oils you will need the center for your mixtures and possibly for additional mixing area as well.

Oil Palette

For oils I use two large size, 12 x 16-inch (30.5 x 40.7 cm) Masterson palettes, side by side, into which I place 12 x 16-inch (30.5 x 40.7 cm) paper palette pads—the kind with the waxy surface. (I do not use the individual palette paper sheets that may come with the palette, nor do I use the sponge.)

My "main" palette, shown at top, is used for the colors straight out of the tube. The other palette (above right) is used for any color mixing I need to do. I then transfer the paint mixtures to the center area of the main palette as you can see in the photo above. I find that my painting goes much smoother if I have my piles of paint—both tube colors and mixtures—ready for me to dip my brush or palette knife into.

The amount of oil paint you need to squeeze out will vary a bit from color to color depending upon the amount of each color you will need for your painting session. I try to find a balance between having so much that it might go to waste and having too little. Remember—you can't paint without paint! So don't be too stingy. By the same token, you can always add more if you run out. I usually squeeze out approximately a quarter to a half teaspoon, depending on how much painting time I think I have before me that day. The Holbein Duo Aqua Oils dry a bit faster than traditional oils, but remain usable for a couple of days or more, quite unlike the acrylics.

Here's another tip for organizing your oil colors: use a plastic utility case with compartments and stand the tubes up in the same order as they go onto the palette. Then you can easily find a color you need without rummaging for it.

There are so many things to think about when painting that we need as few distractions as possible. Logical and practical work habits help to keep distractions at bay, allowing us to focus on the artistry of the painting more than the nuts and bolts of it. Consistently arranging your palette in a logical manner is just one simple thing you can do to smooth the way for creativity, but it is an important one!

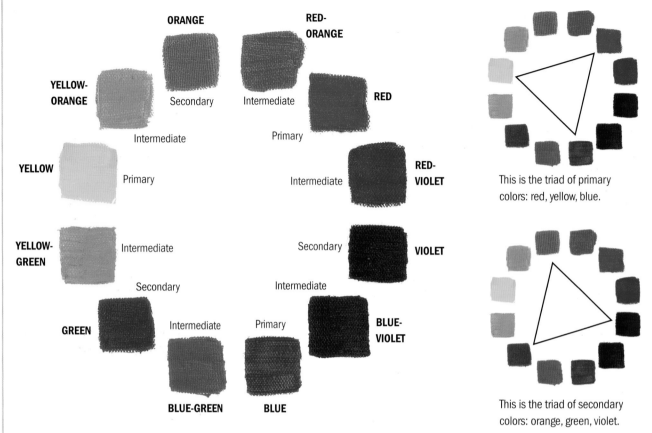

ORANGE
Secondary

RED-ORANGE
Intermediate

YELLOW-ORANGE
Intermediate

RED
Primary

YELLOW
Primary

RED-VIOLET
Intermediate

YELLOW-GREEN
Intermediate

VIOLET
Secondary

GREEN
Secondary

BLUE-VIOLET
Intermediate

BLUE-GREEN
Intermediate

BLUE
Primary

This is the triad of primary colors: red, yellow, blue.

This is the triad of secondary colors: orange, green, violet.

Mixing Colors

Mixing color in acrylics—especially when you use them like watercolor—is very easy. You barely touch the colors to each other and they mix immediately. Mixing oil paints, on the other hand, is a very physical and time-consuming thing. I have to admit that mixing oil color is my least favorite thing to do when painting with oils, and is the reason I use so many different oil colors. You will see that I use many colors that are already mixed with white (or even with other colors) in the tube—and that means less time I must spend mixing the colors and values I will need for the painting at hand.

Nevertheless, even if you use all the colors on my list and all the mixture formulas in this book, it will be extremely helpful for you to learn some basic color mixing facts. You will use this information when using acrylics and oils both.

Triadic Color System Color wheels are an easy and pleasant way to learn about the basic color principles we will be talking about in this book. Let's begin by familiarizing ourselves with a few of the terms you'll see on the color wheels above,

which simply show the TRIADIC COLOR SYSTEM. Here is the triadic color system in a nutshell:

• All colors are combinations of the three PRIMARY colors that make up the TRIAD of red, yellow and blue.

• Mixing two primaries together produces a SECONDARY color—secondary colors are: orange, green, violet. Red and yellow produce orange. Yellow and blue produce green. Red and blue produce violet.

• Mixing a primary with a secondary produces an INTERMEDIATE color: yellow-orange, yellow-green, blue-green, blue-violet, red-violet or red-orange. These are the basics you see above. Going a little further:

• TERTIARY colors are mixtures of two secondary colors. They are olive, citrine and russet.

• Mixing all three primaries together produces a gray, black or NEUTRALIZED color.

• COMPLEMENTARY colors are those that are located directly opposite each other on the color wheel. Complementary colors provide the most color contrast possible. Mixed, they produce grays or neutrals and earth colors. To slightly gray or subdue a color, you can mix a little of its complementary color into it.

Warm and Cool Colors "Warm" and "cool" are terms used for color that you will hear over and over, so let's talk about them. I think it is easier to understand the meaning of warm and cool color when you realize there are really two separate definitions of the terms.

The first definition is more or less absolute. According to this definition, the warm colors are red, orange and yellow; the cool colors are green, blue and violet.

On this particular color wheel orientation (at right), the colors that are placed in the top half are considered to be warm while the bottom colors are considered to be cool.

The second definition describes the terms—"warm" and "cool"—as being relative and means that any color can be warmer or cooler depending on what color it is compared to. For instance, one red can be warmer or cooler than another red depending upon where it fits into the color wheel.

Now look at yellow on the next color wheel (below right). It's easy to see which yellow would be considered warmer and which cooler—the warmer yellow leans in the direction of orange and the cooler yellow leans in the direction of green.

With red, the warmer red leans in the direction of orange and the cooler red leans towards violet.

Warm and cool blue are harder to understand, I think. Here's why: If you add yellow to blue to make green, you're warming the blue up because yellow is a warm color. If you add red to blue to make violet, you're still warming it up since red is also a warm color. If both directions are warmer than the blue itself, how can one be considered warmer and the other cooler? I don't know! And that is hard for someone like me who likes to have every "i" dotted and every "t" crossed! All I can tell you is that the greenish blue is generally considered to be the cooler and a violet-tinged blue is considered to be warmer—even though many people feel that a greenish blue looks warmer to them. Just remember that the triadic color wheel and the language used is merely an attempt to organize color and explain how colors behave in practical usage for the painter.

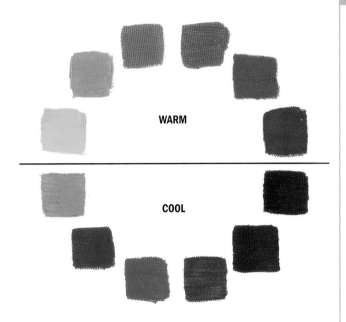

Definition 1: The "absolute" definition of warm and cool colors says that yellow, orange and red are warm, and green, blue and violet are cool.

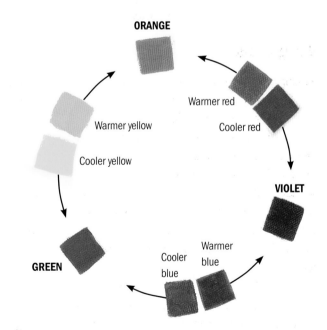

Definition 2: The "relative" definition of warm and cool colors says these terms are relative: any color can be warmer or cooler depending on what color it is compared to.

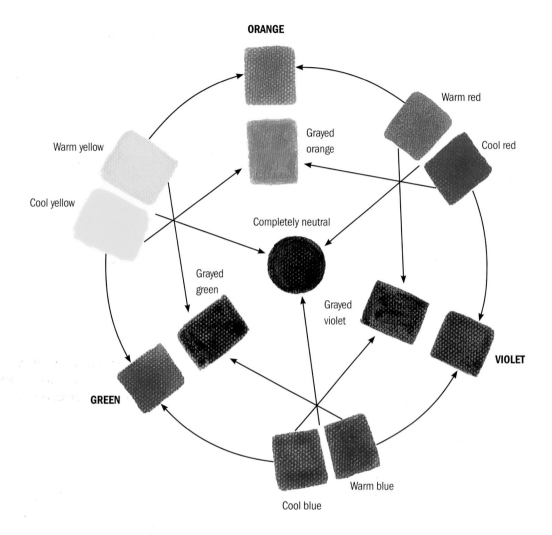

ORANGE

Warm red

Grayed
orange

Cool red

Warm yellow

Cool yellow

Completely neutral

Grayed
green

Grayed
violet

VIOLET

GREEN

Warm blue

Cool blue

Bright and Grayed Mixtures Still speaking of warm and cool color and how this knowledge will help you to mix the colors you need, the color wheel above elaborates on the theme. In addition to illustrating how bright secondary colors can be mixed, this color wheel shows some grayed mixtures as well. Notice how cool yellow and cool red combine to make a less bright orange. Why? The cool yellow leans toward green—the cool red leans toward violet. Therefore, you are mixing red and yellow *plus* the tiny amount of cool color that is inherent in each of these primary colors. Therefore, the orange is grayed down a bit, going toward brown and then to completely neutral, meaning no identifiable color in the mix.

Completing the Triangle Now let's study the color wheel shown at the top of the next page. Here we have a triad—or triangle—of three primary colors, indicated by the dark triangle, with a lighter, secondary triangle that is rotated two color spaces (on a 12-color wheel), with the three points marking the positions of the secondary colors. The intermediate colors would be located between the primary and secondary colors.

If you examine the positions of the primary and secondary colors you will see that if you mix complements together, you will actually be mixing some of each of the primaries together, what I call "completing the triangle." For example: green and red are complements—red is a primary

color, green is a secondary color made up of yellow and blue—voilà!—all three primary colors are represented. This is why mixing complements produces grayed—or neutralized—colors. Therefore, when you want bright, clean color rather than "grayed down" color, avoid "completing the triangle."

By the same token, when you do require subdued color, or perhaps grays and browns, you now know that you will actually need to have all three primaries represented in those mixtures. Here's an example: if you need a more restrained red, mixing a bit of green—or yellow-plus-blue—into it will subdue that red—a little or a lot. It depends upon how much green (or yellow + blue) you add to the red. It is the ratio that is important. If your mixture of the three primary colors balances the mixture to the point that your blend becomes a "non-color"—true gray—you will need to un-balance it by adding more of the particular primary color that is needed to nudge the mixture towards the grayed-down (but not totally gray!) color you are shooting for.

The color wheel below right shows the complement of each of the twelve colors on the color wheel—complements are directly across the wheel from each other.

The main thing to remember is that any time a third primary color—even in the most minute amounts (as in the reddish tinge of Ultramarine Blue, for example) is added to a mixture, that mixture will begin to move in the direction of neutral—which is what you get when all three primaries are mixed together. This is neither bad nor good—but simply a fact of how color usually behaves. I say *usually* because there are some colors that seem to "break the rules." This basic premise of triadic color theory is simply an attempt to make sense of color. Warm and cool are the key factors. However, the purity of a color is also a factor. You must combine theory with what you actually discover in practice about how the colors that you have on your palette mix with each other.

You may have noticed—if you have compared all of these color wheels to each other—that the colors don't match exactly. One of the color wheels was painted with the Holbein Duo Aqua Oils that the painting demos in this book were painted with. One was painted with standard color name oils, and one with acrylics. This points to the fact that, while colors may vary significantly among brands and mediums, the basic color principles still apply.

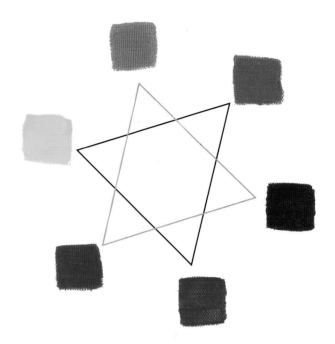

Note the beauty and symmetry of the triadic color wheel! The bold triangle points to the three primary colors; the fine triangle is rotated two color spaces over and points to the three secondary colors.

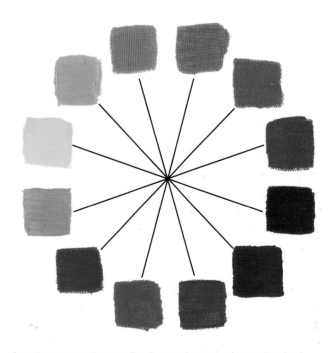

Complementary colors are directly opposite each other on the wheel.

MAKE YOUR COLORS ZING!

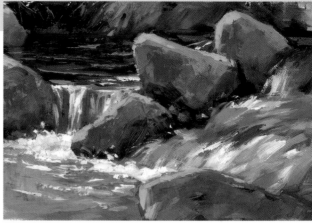

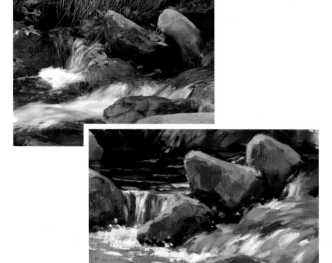

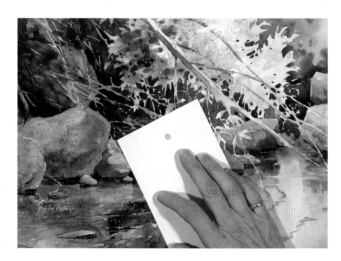

Gray and brown rocks do not have to be painted in those correct but unexciting colors for them to look like rocks! I learned early on that value (dark and light) is of overriding importance, that if you get the values correct, you can use a wild color scheme and still produce a realistic-looking painting. I pushed the color in the little study at left farther than I usually do in order to make the point––the black and white version (above) is the proof!

Using Color as Value

COLOR! Dazzling, delicious, seductive color! We artists do love color, don't we? And yet, using brilliant color successfully can be quite tricky. My goal is to simplify the basic principles of color in order to make the use of color less mysterious—and to make it easier to use color imaginatively and simply for the pure pleasure of it.

Here's the most important thing to remember about color: While color may be one of your highest priorities in terms of emotional response, when compared to shape and value, *color is the least important element* of the three. The truth is that if you get shape and value right, you can use almost any color scheme you please.

You may be thinking, "This is a book about color and yet you tell me that color isn't important?" No, I didn't say that. It's because color is so important to us color-lovers, that it is vital that you get its value correct and then applied to the canvas in shapes that "work" for the subject. This shape-and-value idea is an essential key to using color to its fullest, most delicious potential!

Are you familiar with the term *value?* Value simply means the lightness or darkness of a color—a simple idea. However, learning to correctly judge the lightness or darkness of a color isn't always easy. A simple tool that will help is a white or gray card with a hole punched in it—I use a white index card. When a sample area is viewed through the hole in the card, it is isolated from the many, many values, colors and other elements in the photo, painting, or even the colors on your palette, that distract our eyes from seeing the true value or color. Once isolated, and compared to the flat white of the card, you will immediately see the true light, medium and dark— the value—and the accurate color as well.

When using your index card tool to evaluate color or value, remember that you are not necessarily assessing the "correct" color (or any other element for that matter) in order to slavishly reproduce it, but rather to understand the truth of the subject (at least as defined by your camera) before changing it to fit your own artistic vision. First evaluating the factual elements of your picture makes any change a conscious decision—not a formless idea without rhyme or reason—and conversely offers the first step to an alternative to simply copying a photograph.

Spring Arroyo I—Toned canvas

This canvas has been toned with acrylic paint. I prefer a warm tone, usually orange. Tone can be flat, variegated, or even multicolored.

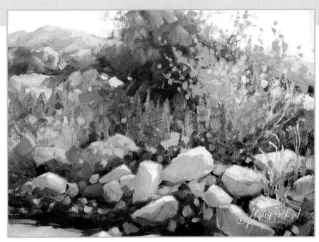

The painting is then finished in a conventional oil painting manner.

Spring Arroyo II—Monochromatic under-painting

This is a monochromatic under-painting with a full range of values.

The painting is then finished with oils, but the shapes and values have been "locked in" with the acrylic under-painting.

Spring Arroyo III—Full color, definitive acrylic under-painting

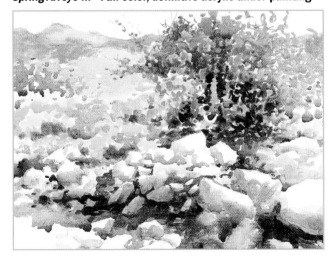

This full-color acrylic under-painting locks in the composition.

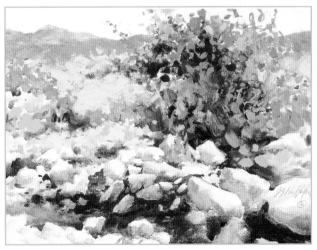

The painting is then finished with oils, but most of the acrylic under-painting still shows.

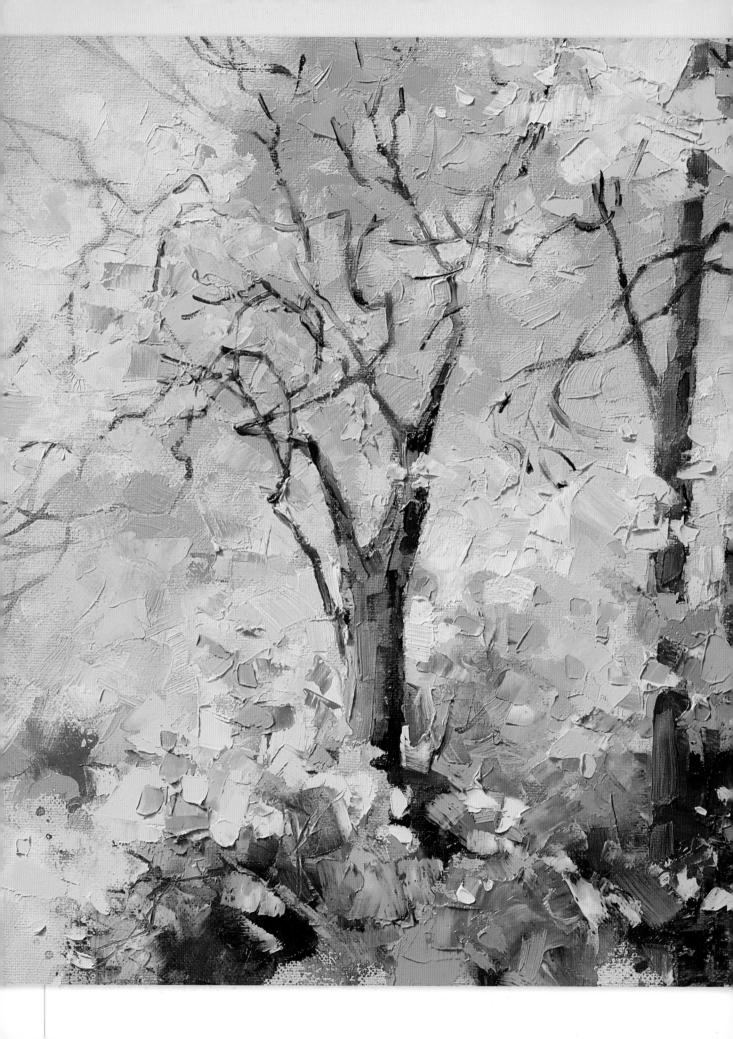

Autumn Ablaze, 11 x 14 inches (28 x 36 cm), oils over acrylic on canvas

Autumn Ablaze

My husband and I enjoy hiking in our beautiful state of Arizona whenever we get a chance. He is the very soul of patience with my constant picture-taking! The photos are invaluable to me as reference material and I treasure them. The photo that inspired this painting was taken in West Fork Canyon, an off-shoot of Oak Creek Canyon up-creek from Sedona, Arizona, near where we stay every year for our anniversary week. It is a magical hike as you can see. I have done many paintings from photos taken in this canyon.

On this day, the colors of the leaves were so intense that the leaves acted as stained glass through which the sun shone, rose-tinting even the ground. Although the composition and colors in the photo were the vehicle, my memory of the gold and rosy glow all around us was my primary motivation for painting this scene. The color was even in the air!

COLOR MIX CHARTS

ACRYLIC COLORS USED

Place the following acrylic colors on your palette as you need them. Use a brush to create the mixes shown in the chart at right.

Nickel Azo Yellow
Transparent Pyrrole Orange
Quinacridone Magenta
Permanent Violet Dark
Dioxazine Purple
Cerulean Blue Deep
Turquois (Phthalo)

Acrylic Mixes

Mix A1
Nickel Azo Yellow +
Quin. Magenta
1:a touch

Mix A2
Trans. Pyrrole Orange
+ Nickel Azo Yellow
2:1

Mix A3
Trans. Pyrrole Orange
+ Perm. Violet Dark
3:1

Mix A4
Quin. Magenta +
Trans. Pyrrole Orange
3:2

Mix A5
Trans. Pyrrole Orange
+ Dioxazine Purple
2:1

Mix A6
Trans. Pyrrole Orange
+ Dioxazine Purple
1:1

Mix A7
Dioxazine Purple +
Turquois (Phthalo)
2:1

Mix A8
Nickel Azo Yellow +
Cerulean Blue Deep
1:a touch

OIL COLORS USED

Place the following tube oil colors on your palette. Use a palette knife to create the mixes shown in the chart at right.

Titanium White
Cream
Marigold
Yellow Grey
Orange Grey
Caramel
Deep Yellow
Jaune Brillant
Orange
Rose Grey
Purple Lake
Light Magenta
Rose Violet
Mauve
Lilac
Lavender
Cerulean Blue
Cobalt Green

Oil Color Mixes

Mix 1
White + Deep
Yellow + Marigold
4:1:1

Mix 2
White + Deep
Yellow + Marigold
5:1:a touch

Mix 3
Cream + Deep
Yellow
3:1

Mix 4
Light Magenta +
Deep Yellow
2:1

Mix 5
Cream + Light
Magenta
2:1

Mix 6
Light Magenta +
Rose Violet
2:1

Mix 7
Mauve + Jaune
Brillant
2:1

Mix 8
Lilac + Rose
Violet
5:1

Mix 9
White + Lavender
+ Orange
1:1:a touch

Mix 10
Cobalt Green +
Marigold + White
3:1:1

Mix 11
Cobalt Green +
Marigold
1:1

Mix 12
Cream + Cobalt
Green + Marigold
5:1:1

REFERENCE PHOTO AND DRAWING

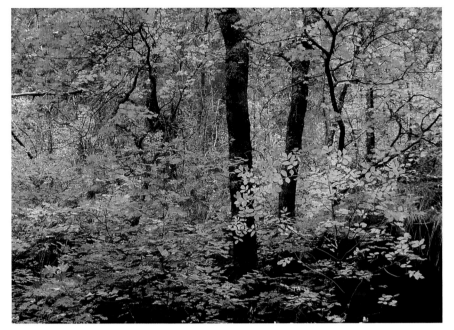

Reference Photo

My husband and I take the same hike through West Fork Canyon near Sedona, Arizona, almost every November and this was the most beautiful we've ever seen it. I think we accidentally hit it at the absolutely perfect time that year and this is what the foliage actually looked like that day. It was a hike of seven miles of oooh-ing and aaah-ing!

I used a digital camera but none of the colors have been altered except as through the camera's built-in image capture system.

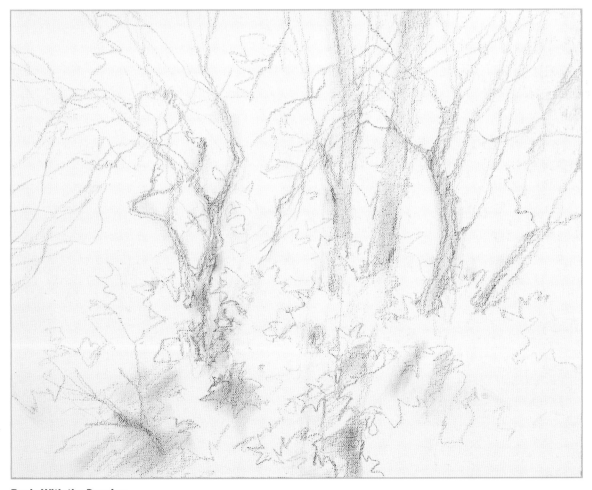

Begin With the Drawing

Loosely draw or transfer the composition onto the canvas using a soft pencil. Use your finger to smudge the tree trunks and some of the darker areas of the foliage. A traceable line drawing for this painting is available on page 137.

BEGIN WITH AN ACRYLIC UNDER-PAINTING

1. Tree Trunks

With fluid acrylics used as you would use watercolor, begin by painting the tree trunks. First, "paint" with clear water, then drop in mixtures of medium and dark colors using Permanent Violet Dark and acrylic mixtures A3, A6 and A7.

A note about acrylics: Since we are using fluid acrylics as watercolor most of the time——and adding various amounts of water to adjust their values from light to dark——the colors will be continually mixing and running together. Refer to the acrylics chart on page 30 only to get a general idea of the colors and strengths you are aiming for, rather than trying to mix the colors exactly.

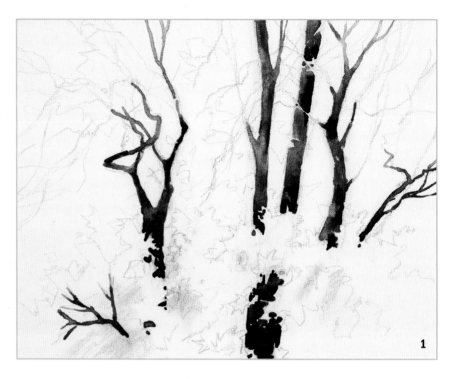

1

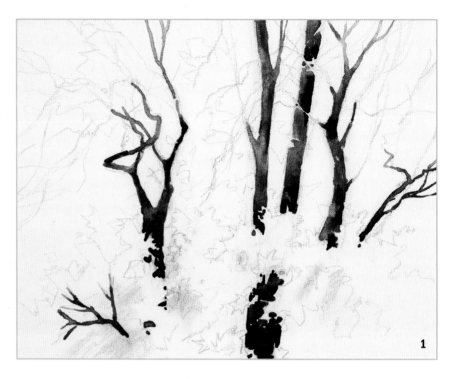

2

2. Branches and Twigs

Paint the smaller branches and twigs, using the same color mixtures as before. There's no need to paint every single twig—it's the pattern that they create that's most important. You will paint over some of them with oil later, and probably add some more as well. Allow some of the twigs to be lighter and some darker.

This is a good time to step back and take a look at what you have accomplished to this point. You have established a critical element to your painting: a pattern of dark colors, a structure upon which the entire painting will "hang." Your composition is "locked in." As you proceed through the paintings in this book, you will find that this technique is common to all of them and you'll notice how this method helps keep you from losing your composition during the painting process.

3

4

5

3. Patterns of Brilliant Color

Now the fun really starts! Brush clear water over the entire canvas. While it's wet, loosely apply patterns of brilliant color. Have the same colors on your palette that you used for the branches but dilute them with more water. Apply the paint right over the trunks and branches, allowing the different colors to mingle and merge at the edges. Tilt your canvas this way and that to encourage the washes to run. Splatter orange and yellow——and even clear water——into the washes when the paint has reached the point where it is just beginning to dry. Use Nickel Azo Yellow, Transparent Pyrrole Orange, Quinacridone Magenta and acrylic mixes A1, A2, A4 and A8.

As I begin this painting, I have it on my table rather than my easel. I often don't transfer the painting to the easel until I begin with the oil painting stage. To me, the acrylic stage is more like a watercolor, which I usually paint almost horizontally, with the table at a slight tilt. I personally find this to be more comfortable. For one reason, I like for the acrylic washes to run and mingle, just like with watercolor.

4. Recessed Areas

Still using the same colors and adding acrylic mix A5, paint the recessed areas of the foliage at the bottom of the painting.

5. Darker Areas

Create more depth in those same recessed areas by darkening the bottom portion even more with the same colors. Don't allow the darker color to creep more than halfway up to the highest parts of those areas. Let dry.

We are now finished with acrylics on this painting and will switch to oils for the remainder of the steps.

6. Background and Foliage

With Jaune Brillant, Light Magenta and oil mixes 2, 3 and 4, paint the background between the branches on the left and use Deep Yellow to create an orange leaf mass at the upper left. Throughout all of the stages, apply paint with both brush and palette knife, going back and forth between the two implements. This will add exciting variations of texture to your painting.

8. Upper Tree Canopy

Working your way across the top of the painting, use oil mixes 4 and 6 to create more colorful foliage in the upper tree canopy.

7. Tree Trunk and Twigs

Add color to the far left tree trunk with Deep Yellow, Lilac, Lavender and oil mix 8. Remember that it is fine—even desirable—to allow the acrylic under-painting to show through. Add more strokes to the foliage and background. Paint some twigs into the wet foliage with Purple Lake.

Continue to fill out the leafy canopy on the far left and don't neglect the background around the main tree trunk.

9. Lighter Foliage in Center

Add lighter foliage colors in the center top to create a leaf mass, allowing twigs and branches to show on either side of the mass. First paint with oil mix 3, then brush over it with mix 2, taking care not to "dig" into the wet paint. Remember to "frost the cake" with the lighter color. Likewise, create another leaf mass a bit lower, at about the center of the painting.

Color Lesson #1: USE UNEXPECTED COLORS TO DEPICT BRILLIANT FALL FOLIAGE

When I'm painting a scene with lots of beautiful fall foliage, I don't reach for the usual leaf colors you often see in such paintings. Instead, I have a lot of fun using color that isn't exactly what you would expect to see. Let me point out the three main instances of this arbitrary use of color in *Autumn Ablaze*.

Example 1: Color as Value. First, look at the tree trunks, especially the most prominent one on the left side of the painting. Because of its value, it still reads more or less as brown. But it was painted with purple, orange, magenta and Purple Lake.

Example 2: Analogous Colors. Next, in the trees' canopies, the use of analogous colors of light magenta, peach, orange and a vari-

ety of yellows creates a nice glow of color. I had a beautiful reference photo to work from. That, paired with my memory of that glorious place and the astounding glow of color all around me, led me to use this method to record not only what I saw, but also the joy I remember feeling during that hike, snapping photos every few minutes!

Example 3: Contrast. Finally, with all that bright color in the upper two-thirds of the painting, some balance in the lower right was called for. I chose to add a few touches of cool blue, set off by grayed and darkened orange. Again, not exactly what you'd expect, but appropriate in value for the shadowy area and with a strong enough contrast to help provide balance in the painting.

Here's a quick study of the same scene done in the usual fall colors, the ones painters often grab just out of habit. Compare this study to *Autumn Ablaze* below. Can you see the difference?

Autumn Ablaze puts into practice three of the ways we learned about on pages 22-24 to add brilliance and excitement to our paintings.

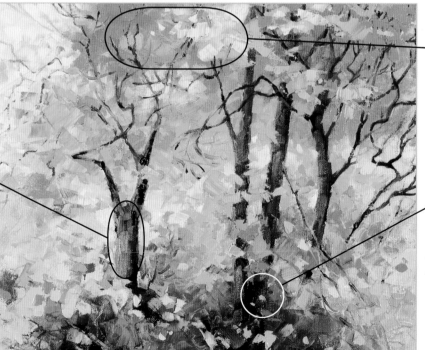

Example 1: Color as value (see page 22).

Example 2: Analogous colors (see page 24).

Example 3: Contrast (see page 24).

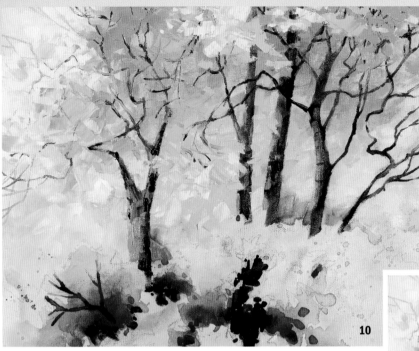

10

11. Foreground Bushes

With a palette knife, add Light Magenta and oil mixes 5 and 6 to the background area to the left of that same tree. Also use your palette knife to add Orange Grey, Caramel, Purple Lake and Lilac to the foliage in the lower bushes.

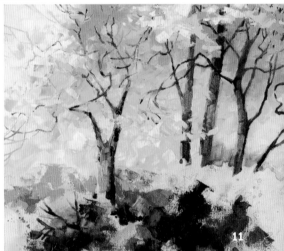

11

10. Trunks and Foliage

Begin adding purples and oranges to the trunks on the right side of the painting and add more Deep Yellow and Orange to the upper right foliage. Curve your strokes around clockwise towards the right edge of the canvas in order to create a leaf canopy.

Add a larger strip of orange to the sunlit side of the far left tree trunk.

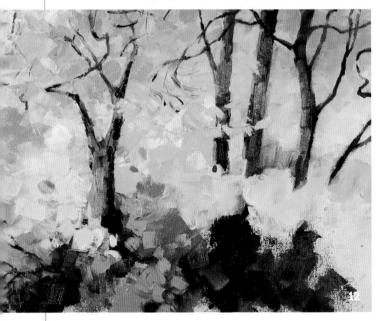

12

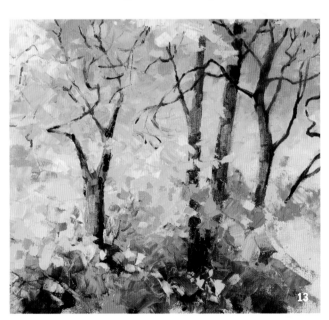

13

12. Foreground Bushes

Apply more colors to the bushes with strokes of Cream, Yellow Grey, Orange, and touches of greens using mixes 10, 11 and 12. "Scrub" some Cream and Marigold over the tops of the bushes to the left. Work the background right up to the edges of the main trunk.

13. Foreground Bushes

Continue to flesh out the bushes with more strokes of the same colors, making sure to add some lighter flicks of color over the darker shades to indicate leaves that are closer to the viewer. Put touches of Cerulean Blue and Lavender in the darker recesses of the bushes. Use Lilac for the far lower left branch in the bush.

14.

14. Unexpected Colors

Strokes of Lavender and mix 9 along with mixes 4 and 5 will add a touch of the unexpected in that lower right foliage. Add a branch hanging down from the middle trunk of the grouping of trees on the right, plus some additional twigs on the lower far right.

15.

15. Sunlit Background

Add a bit more sunlight—notice where I have added a lighter color, mix 2—to the background right up next to the far left tree trunk, carrying it to the opposite side of the trunk as well. Also, look up under the canopy just left of center to where I added the same color to the background, around and between the twigs.

16.

16. Check Your Work

Take a final look at your entire painting to see if there are any areas that could be improved. After careful consideration, I decided that the far left tree didn't really look finished. So I added another branch. As you add your new branch, make sure to overlap the twigs of the upper part over the previously painted twigs so that it doesn't look like a last minute add-on. Now the painting is finished!

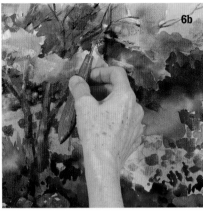

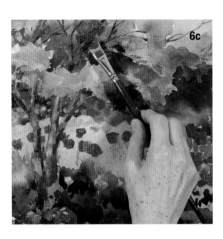

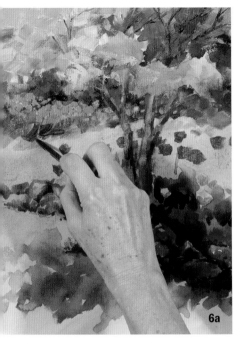

6. Tree Foliage, Twigs and Tulip Stems

Starting in the upper left corner of the painting, apply broken color strokes of Yellow Grey, Blue Grey, and oil mixes 7, 10, 12 and 21, plus touches of mix 20, to the tree foliage. Start painting in some twigs and branches with Rose Grey, Purple Lake and Lilac. Paint the orange tulips in the far left with mix 6 and the surrounding blue flower mass with Lavender, using Prussian Green at the base. Very loosely extend the orange and blue flowers through the tree trunks.

The three photos above show how you can use three different implements—a dull pen knife, a palette knife and a brush—to remove paint as well as add it. In photo 6a at left, I'm using a pen knife to scrape away tulip stems out of the darker paint, leaving the underlying acrylic color to show through. In photo 6b above, I'm using the edge of a small palette knife to apply thin twigs. Photo 6c above right shows using the brush and some violet to add unexpected color. The green is expected in the shadows of a green tree, the violet is not. I like to spice things up a bit with "creative color."

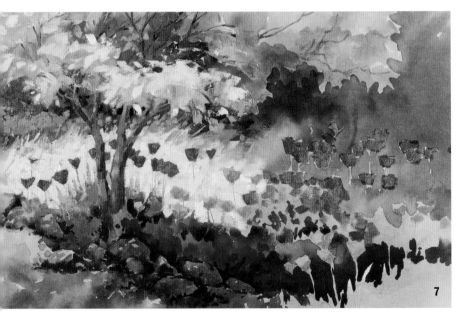

7. Sunlit Leaves and Grass

Continue to use these three techniques as you carry the tree foliage across to the right as shown, then paint the sun-struck grass with mixes 20 and 21 between the red tulips under the tree. Refine the shapes of the red and orange tulips as you paint the pale grass around them. Feel free to use red—Permanent Rose—and orange mix 6—to re-claim the tulips if you lose them in the negative painting process.

Put some Cobalt Green in the shadow area to the immediate left of the tree trunk. Carry it through to the right side of the trunk.

8. Treetop at Right

Go back up to the leafy treetop at the right side and add Cerulean Blue and mix 15 to the other colors you've been using in the foliage.

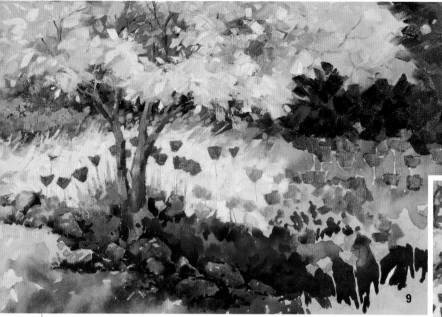

10. Dark Background

Carry on by painting the background further down behind the red tulips and paint the tree leaves down over the dark, partially overlapping one of the tulips. This overlap will create some depth.

9. Dark Background

Now add the dark background to the far right, adding Green Blue and mix 14. Again, paint the background around the red tulips. Paint the suggestions of pink roses onto that dark background with Light Magenta and mix 9.

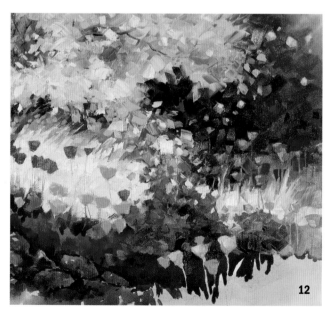

11. Upper Tree Canopy

Finish painting the tree canopy at upper right, adding a few leaf strokes over the background and a few more rose suggestions. Paint the red flowered bush to the right, then bring the leafy branch down to partially overlap it. Paint a green and lavender mass to the lower right of the red flowered bush, again painting around the orange tulips.

12. Light Grasses

Continue to refine that far right area with the path of light grass just beyond the foreground shadows, then extend the reds across as well. Work these flowers and foliage that are in shadow down and around the orange tulips at bottom right. Use mix 2 for the sun spots on those tulips.

Color Lesson #2: USE COLOR AS VALUE

Use color as value? How does one do that? First, you must learn to see colors in terms of light, medium and dark. Squinting your eyes really helps you to see the value rather than the color. Another tool that is helpful is a piece of red acetate. If you look at a subject through red acetate, you will see value only, not color. It takes a bit of practice to train your brain to think and see in terms of value—but it is so terribly important to your craft.

Now, as you compare the full-color version of *Gone Wild* shown below with the black and white version, I want you to look first at the light area of foliage in the tree's canopy. I've indicated this area

with an asterisk. In the black and white picture, notice how that light clump of foliage is made up of strokes of paint that are very close in value, creating a very believable foliage shape. Now look at the same area on the color picture—that clump of foliage is made up of pink, green, yellow-green, blue-gray and lavender. There are several complementary-color contrasts in that group of colors—and certainly not typical leaf colors. Yet, because they are so close in value, that clump of foliage "hangs together." You can see that using this concept of color-as-value is an excellent way to become adventurous with color!

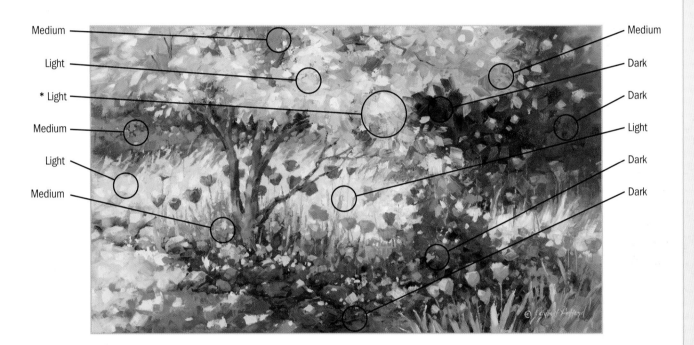

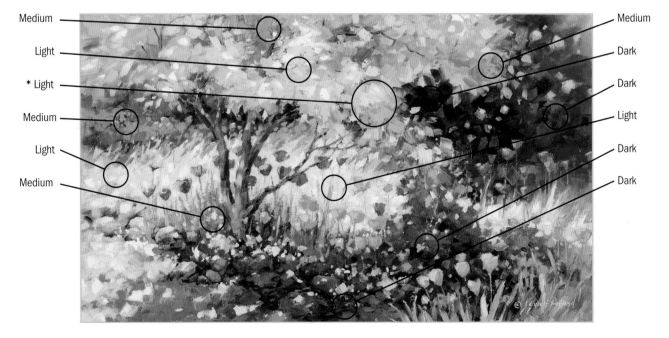

14. Sunlit Grasses and Tree Leaves

Add strokes of mixes 1 and 18 to the strip of sunny grass and a few strokes of the same mixes up in the tree. This will add flickering sunlight to the scene.

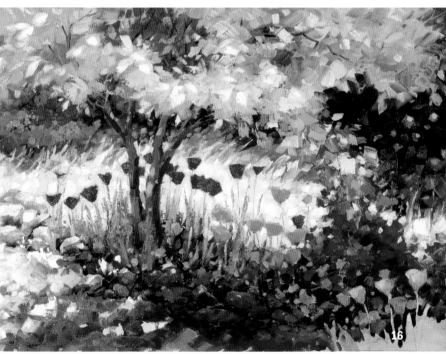

13. Rocks at Left

Start painting the rocks at the far left with Rose Grey and mixes 5, 7 and 10, plus touches of mix 6 where the shadow hits the rock that is right at shadow's edge.

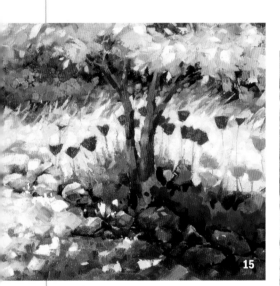

15. Grass Below Rock Border

Now paint the grass below the rock border in the lower left corner of the painting, following the same sequence as you did for the grass that runs through the middle of the painting. Start with mixes 20 and 21. Second, add strokes of mixes 1 and 18. Paint the shadows with Cobalt Green and mix 12. Don't forget the dappled light!

16. Tulip Leaves and Blue Flowers

Add some brushstrokes to suggest tulip leaves and perhaps some long grasses under the tree. Add some dappled light to the rock at the tree's base with Jaune Brillant. Add touches of Lavender to suggest blue flowers under the tulips. To the blue flowers you just started, add touches of Cerulean Blue to the darker areas and Lilac to the lighter ones.

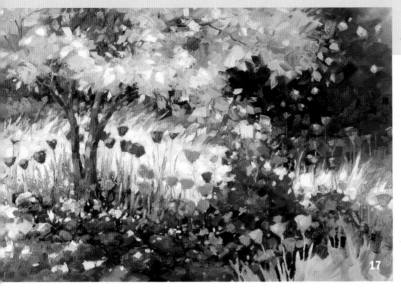

17. Tulips, Shaded Rocks and Sunspots

Add some Light Magenta to the tops of some of the red tulips and Jaune Brillant to the orange tulips to represent sun splashing onto them through the leaves. Add some Purple Lake and Blue Violet to the shaded rocks and a few Jaune Brillant sun spots. Don't use the lightest mix 5 for the sun spots because the value contrast would be too jarring. Use Cobalt Green and mix 9 to begin the lower right corner.

18. Tulip Leaves

Loosely brush in some various greens for the long tulip leaves in the lower right corner.

Check your tulips—do any of them need refining? Try making a few of the orange tulips a bit more interesting by adding petal details rather than leaving them as simple cup shapes.

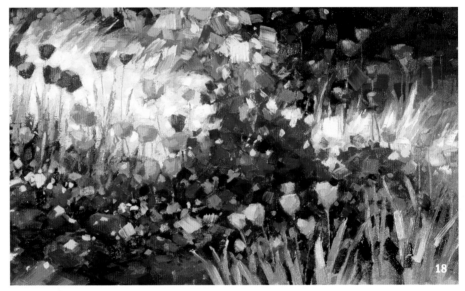

19. Check Your Work

Take a final look at your entire painting to see if there are any areas that could be improved. This is where I decided that the tree needed another branch. This small branch coming off the right side of the trunk helps to balance out the composition better. I made sure to have the branch and twigs overlap some of the flowers. These final touches make all the difference in a painting!

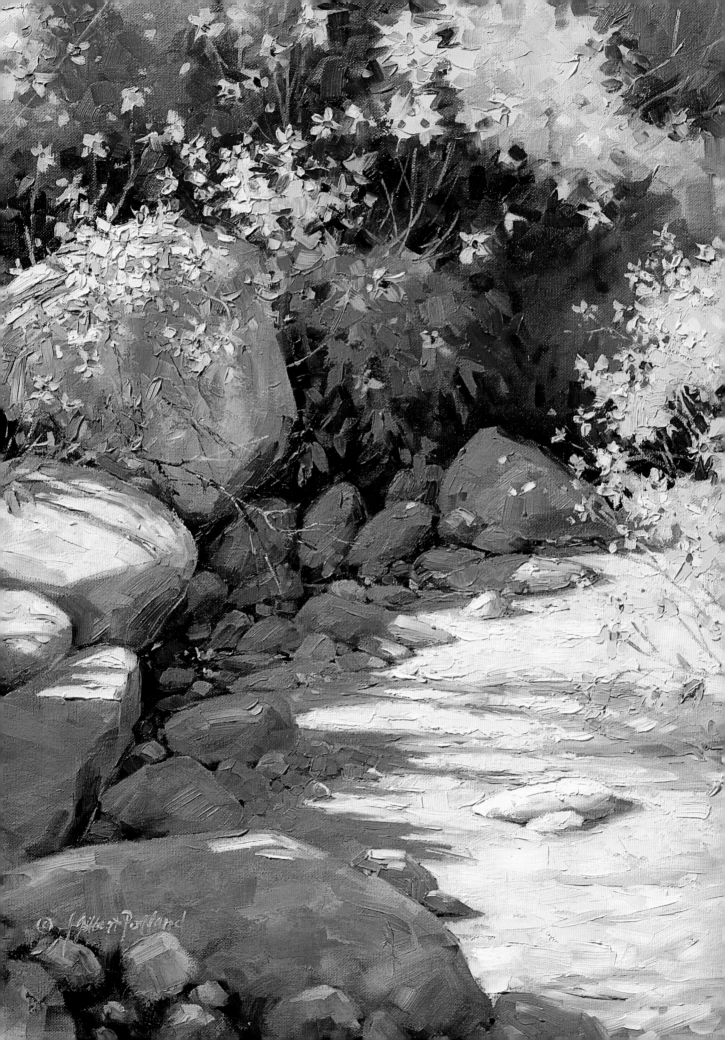

Dutchman's Gold

Another hike, more painting material! My husband and I had packed a lunch and as we ate our repast in this sandy wash, we were totally surrounded by gold. It wasn't a hot day, but the sun and exertion of the hike caused us to look for some shade in which to rest and dine. Cozied down in the gulch, the yellow brittlebush hanging over our heads, the thick foliage below the gold was deeply shadowed, the rocks and sand were cool. I sometimes fancy that this gold is really what the gold of the "Lost Dutchman Mines" is all about.

For me, painting is as much about reliving memories as it is about creating a painting. When I paint, the memories come back to me vividly, enabling me to almost be there—in that moment and in that place—all over again. When I paint from a photo taken many years ago, the experience can be bittersweet. But there is always pleasure and fond reminiscence along with the poignancy. In so many ways, painting is more than simply making a pretty picture. I always advise that, while there is much to be learned in terms of "nuts and bolts" by following along with an instructor's painting, eventually you should paint from your own photos and your own experiences. Your painting and life experience will be much richer for it.

Dutchman's Gold, 20 x 16 inches (51 x 41 cm), oils over acrylic on canvas

ACRYLIC COLORS USED

Place the following acrylic colors on your palette as you need them. Use a brush to create the mixes shown in the chart at right.

Nickel Azo Yellow
Transparent Pyrrole Orange
Dioxazine Purple
Cobalt Blue
Anthraquinone Blue
Cerulean Blue Deep
Turquois (Phthalo)

Acrylic Mixes

Mix A1
Nickel Azo Yellow +
Trans. Pyrrole Orange
+ Cerulean Blue
Deep
1:1:1

Mix A2
Nickel Azo Yellow +
Cerulean Blue Deep
1:1

OIL COLORS USED

Place the following tube oil colors on your palette. Use a palette knife to create the mixes shown in the chart at right.

Titanium White
Lemon
Cream
Marigold
Yellow Grey
Deep Yellow
Jaune Brillant
Orange
Rose Grey
Purple Lake
Rose Violet
Mauve
Lilac
Lavender
Ultramarine Blue
Prussian Blue
Blue Grey
Green Blue
Cobalt Green
Prussian Green
Green Grey

Oil Color Mixes

Mix 1	Mix 2	Mix 3	Mix 4	Mix 5	Mix 6
White + Lemon + Marigold 7:7:1	White + Lemon + Marigold 1:1:1	White + Marigold 1:1	White + Marigold + Yellow Grey 1:3:1	Yellow Grey + Deep Yellow + Rose Violet 3:3:1	Lilac + Mauve 2:1

Mix 7	Mix 8	Mix 9	Mix 10	Mix 11	Mix 12
Mauve + Jaune Brillant 3:1	Lavender + Mauve 3:1	Lavender + Ultramarine Blue + Mauve + Prussian Blue 3:1:1:1	Green Grey + Lavender 1:1	Cobalt Green + White + Marigold 3:2:1	Green Grey + Marigold 1:1

Mix 13	Mix 14	Mix 15	Mix 16	Mix 17	Mix 18
Cream + Cobalt Green + Marigold 7:1:1	Lemon + White + Cream + Cobalt Green 7:2:2:1	White + Cream + Jaune Brillant 1:1:1	White + Cream 2:1	Yellow Grey + Deep Yellow + Rose Grey 1:1:1	Lavender + White + Orange 3:3:1

Mix 19	Mix 20
White + Ultramarine Blue 3:1	White + Green Blue 3:1

REFERENCE PHOTO AND DRAWING

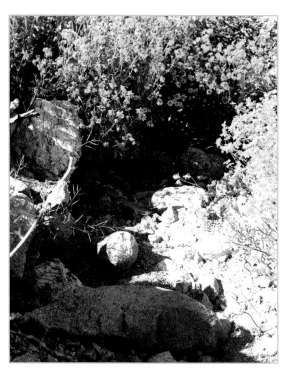

Reference Photo

I think this is a wonderful photograph. Even this photo, though, doesn't do justice to the place—a photo seldom if ever does! What we "see" is heavily affected by our emotions. A camera can only record a morsel of the experience. This is one reason that I exaggerate color: since color is so emotional anyway, that exaggeration helps me put the excitement back in!

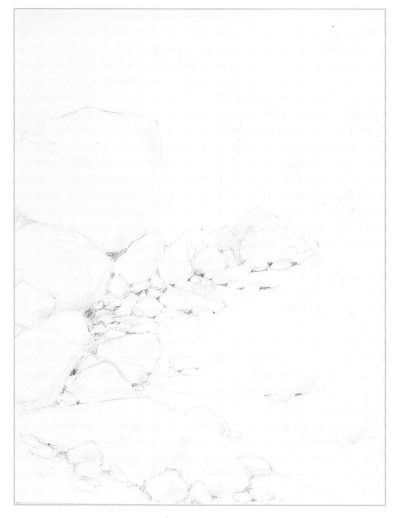

Begin With the Drawing

Loosely draw or transfer the composition onto the canvas using a soft pencil. Use your finger to smudge the trunks and some of the shadowy areas in the rocks. A traceable line drawing for this painting is available on page 138.

BEGIN WITH AN ACRYLIC UNDER-PAINTING

1. Rocks and Shadowed Foliage

With acrylic Anthraquinone Blue, paint the spaces between the rocks. In the upper lefthand corner, wet the canvas with clear water, going around the largest rock and extending the wet area to roughly two-thirds of the way across the canvas and down close to, but not going past, the tops of the rocks. Into this wet area, brush fluid acrylics in Nickel Azo Yellow, Transparent Pyrrole Orange, Cerulean Blue Deep and Anthraquinone Blue. Allow the colors to bleed into the clear water wash, keeping your paint well clear of the edges where the clear water stops. You won't be mixing color on your palette with this painting, but allowing the colors to mix where they touch on the canvas. However, you can refer to acrylic mix A1 on the chart for the color approximation in the upper left corner.

Finish the "lock in" stage. Use the same blues to paint the deep area of shadowed foliage that extends from the center to the upper right corner.

2. Remaining Areas

Paint the remaining un-painted area in the upper foliage area with a diluted Transparent Pyrrole Orange. Continue with the diluted orange until you've covered the entire canvas. Let dry completely.

3. Rocks and Cast Shadows

Apply diluted glazes of Cobalt Blue over the rocks that are in the deepest shadowed area. Continue that same glaze further down to include the rocks and cast shadows closer to the front.

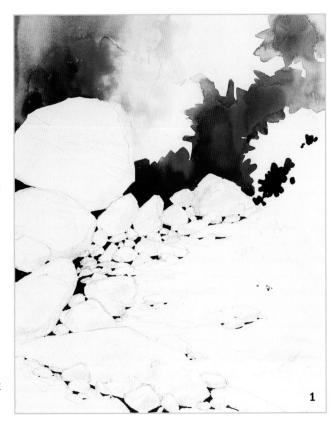

1

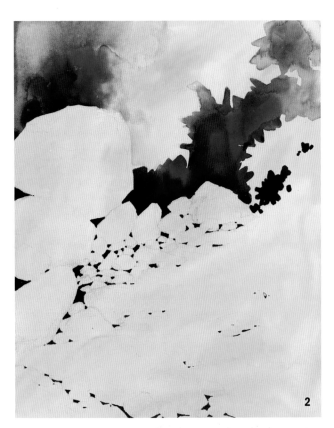

2

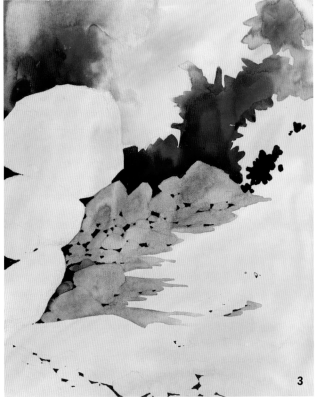

3

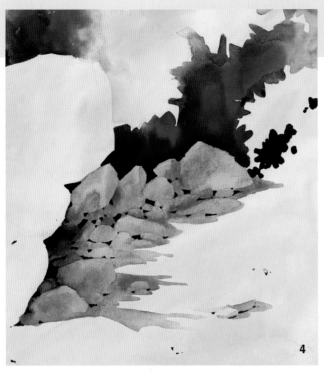

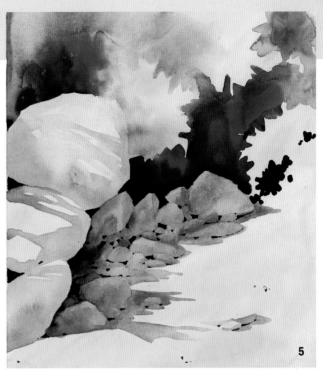

4. Overlapping Rocks

We will now begin to separate some of the rocks from each other. Using glazes of Dioxazine Purple and Turquois (Phthalo), find rocks that are behind others and "push" them back by making them slightly darker in the places where they are behind the other rocks. This creates depth and the sense that some rocks are overlapping others.

5. Cast Shadows

Use the same colors to paint some cast shadows over the boulders to the left. Run those washes down the sides of those same boulders where they turn away from the sun. Paint the topmost boulder and the shadows that are cast upon it in the same manner. Then add a wash of green to the foliage areas as shown, using turquoise with a touch of yellow—see mix A2 for an approximate color.

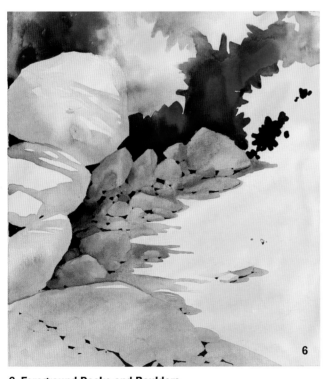

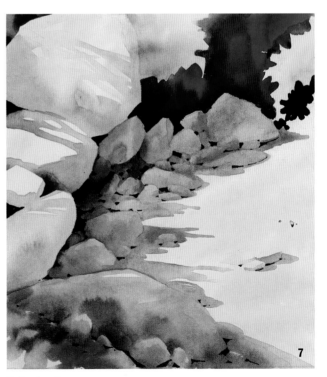

6. Foreground Rocks and Boulders

Apply glazes over the foreground rocks and boulders using mixtures of blues, turquoises and purples, as you have already done on the other rocks.

7. Darker Areas

Make those same rocks and large boulder come forward by darkening the rocks behind and around them. You are now finished with your acrylic under-painting. On to oils!

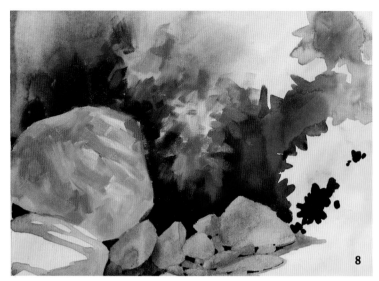

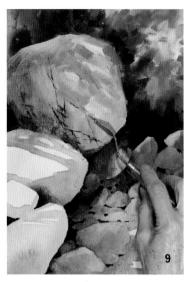

8. Topmost Boulder and Foliage

We'll begin the oil phase with the topmost boulder. Use Yellow Grey, Lilac, oil mixes 18, 19 and 20 on the lower right, and add mixes 5 and 6 to do the remaining parts of the boulder, leaving the sun spots un-painted at this stage. Apply brushstrokes of Prussian Blue, Blue Grey, Prussian Green, Green Grey and mixes 7, 9 and 20 to the adjacent foliage.

9. Line Marks on Boulder

Working on the same boulder, use Purple Lake on the edge of your smallest palette knife to make line marks on the boulder.

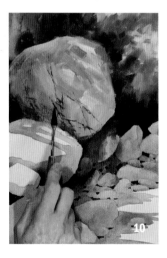

10. Smudgy Texture

Use the flat side of the same palette knife to make a smudgy texture on the boulder.

11. Background Flowering Bush

Scrub in transparent Marigold at the top of the prominent flowering bush in the upper background, then Prussian Green a bit lower down. Paint a thick passage of very dark Prussian Blue and Prussian Green in the deep recess of the bush, then scrape some twigs into the wet paint using the edge of your palette knife.

Add Lavender, Green Grey and mix 11 to the foliage directly to the right of the largest boulder to serve as a base for details to come later.

Apply mix 15 to the "sun spots" on both the top boulder and its neighbor next door down, breaking up the lightness with mix 18 where needed. Add Yellow Grey, Rose Grey and mix 9 to the righthand side of the smaller boulder where it is out of the sunlight.

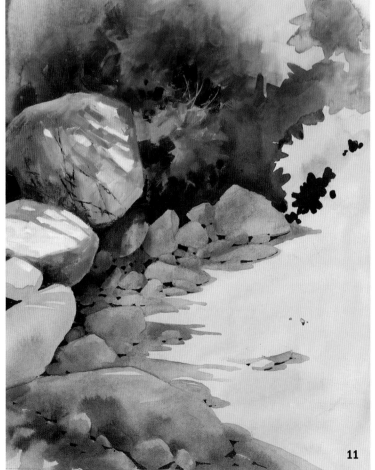

11

12. Yellow Flowers and Smaller Rocks

Now add some yellows—Marigold and mix 2—
and yellow-green—mix 12—to begin building
the flower mass.

To begin building the mass of smaller rocks
to the right of that main boulder, use Rose
Grey, Purple Lake and mix 9.

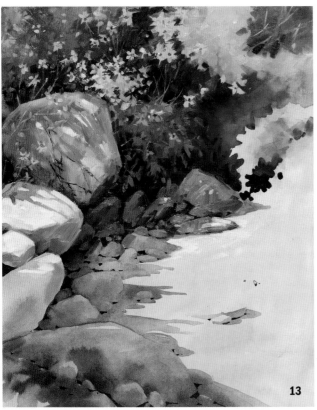

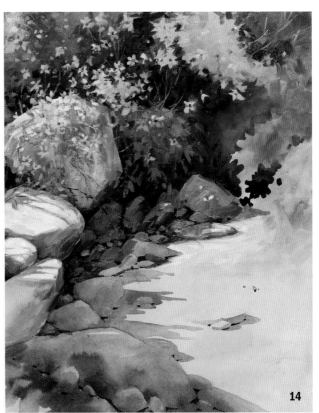

13. Yellow Flowers and Rocks

Add more flowers, some twigs over the boulder, and foliage. Brush some
yellow onto the far right flowering bush. For the flowers in direct sun, use
Deep Yellow for their centers; for the rest use Yellow Grey or Rose Grey,
and Purple Lake for the ones in deep shadow.

In the upper left corner, "smudge in" some yellow—mix 4—to suggest
flowers and add some brushstrokes with Cobalt Green and Blue Grey for
a bit more leaf definition to the right of the boulder—a few more yellow
flowers too!

Down in the rocks, loosely add brushstrokes to the rocks that are
already formed by the acrylic under-painting. This will add texture and
a feeling of bulk and solidity to them. Be sure to paint the sunlit areas
(mixes 15 and 16) as well as the out-of-light areas.

14. Yellow Flowers and Rocks

Brush more yellows over the far right bush, then go back to the bushes
on the left and add still more flowers over the largest boulder, plus more
sun spots and cast shadows.

Continue working on the rocks, adding both warm and cool medium-
value colors such as Rose Grey, Blue Grey, Lavender, and mixes 5, 6, 7,
8, 9 and 17. Use Purple Lake for the deep crevices. Your goal here is to
strike a balance between treating the rocky area as one large mass of
broken color that melts into the shadows, yet giving definition to enough
individual rocks so that the area doesn't look flat. With this combination
of techniques—defining and modeling and using lost edges—work your
way down, finishing as you go.

15. Yellow Flowers and Sandy Wash

Jump over to the bush on the right and apply some lighter yellow to the flower mass. Now start painting yellow flowers. Most of the flowers should be on the outer edges of the bush with just a few inside the mass. It's not necessary or even desirable to paint all the flowers—the viewer's eye will "fill in the blanks"!

Scribble some strokes of Lavender and mix 17 onto the sandy wash. This will be mostly painted over later, but some color will show through to add texture. Notice how the texture goes around the top of the small rock, which defines its shape. This will be a big help later.

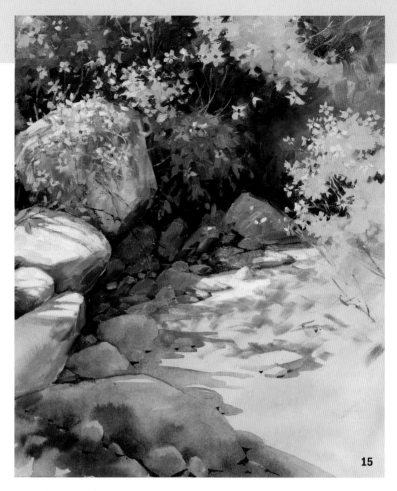

15

16. Sandy Wash and Cast Shadows

Start painting the sand with mixes 15 and 16 and touches of Cream here and there to liven it up. Don't completely cover the texture scribbles from step 15. Add some twigs sticking out over the sandy area. Paint the top of the small rock out in the middle of the wash.

Over that light sand area, add some strokes of mix 17 to indicate shadows cast by foliage or flowers that are to the left of the picture plane and out of our sight. These will contribute to the feeling that the viewer is down in a gulch with foliage all around.

Model the larger of the two isolated rocks in the middle of the sandy wash.

16

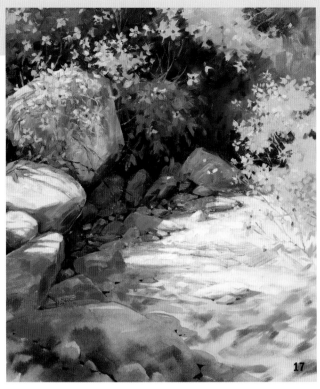

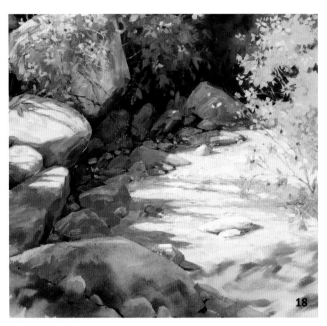

17. Flowers, Twigs and Rocks

Paint some flowers and leaves and a few more twigs out over the sand. Having the flowers overlap in this way will push the sandy path down and pull the flowers forward—more depth! Do that same "scribble thing" in the sand forward of the small isolated rocks.

Add a few yellow paint dabs to indicate flower petals that have fallen into the smaller rocks. Start painting the rocks to the left that haven't yet received any oil paint.

18. Cast Shadows

Work further on the shadows cast over the sand, refining them if necessary with both positive and negative painting. In other words, if the shadow gets too large, come back in against that shape with sand color to refine and define it more to your liking. You can add more flowers too.

Bring the sand on down further into the foreground and paint the cast shadows and small rocks as you go.

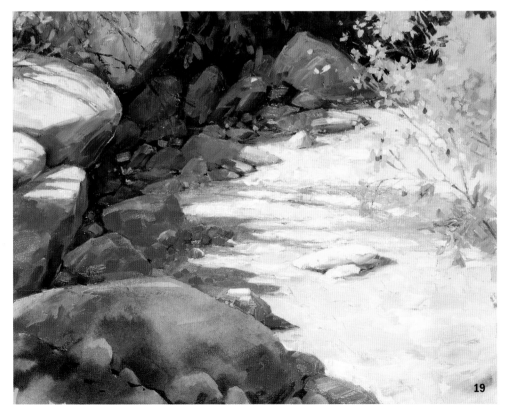

19. Sand and Rocks

Continue the sand on down to the bottom of the canvas. Add more brushstrokes to the rocks as well.

Color Lesson #3: PUT THE "COLOR TRIFECTA" TO WORK

Earlier in the book in the section called "Make Your Colors Zing!" we talked about the *color trifecta*. The three color principles that make up the trifecta—using color as value, using contrast, and using analogous colors—are all clearly shown in this painting. Use analogous colors in the shadows to give them life; use complementary colors to create brilliant color contrasts; and, of course, use color as value. Or, as I often do, use color just for fun!

This is a painting about sun colors and shadow colors, meaning that it is necessary to use extreme color contrasts. Yellow and violet are perfect for this color scheme. Yellow is the easiest color to make

pop forward. Violet, its complement, is our darkest color and easy to gray down when necessary, thereby making yellow and neutralized-and-darkened violet the most contrasting duo: you have value contrast, complement contrast and bright/neutral contrast. Contrast on three counts—and to the max! The variety of cool (analogous) colors—with violets figuring prominently—set off the yellow flowers and the sun-struck rocks and sand quite dramatically.

Do you see how learning the basic color principles—and thinking about them when you paint—will open up new worlds and present you with many exciting color possibilities?

Dutchman's Gold puts into practice the "color trifecta" we learned about on pages 22-24. Compare this lesson to Color Lesson #1 on page 35, where you'll find the same color principles at work in a very different painting!

Example 2: Contrast (see page 24).

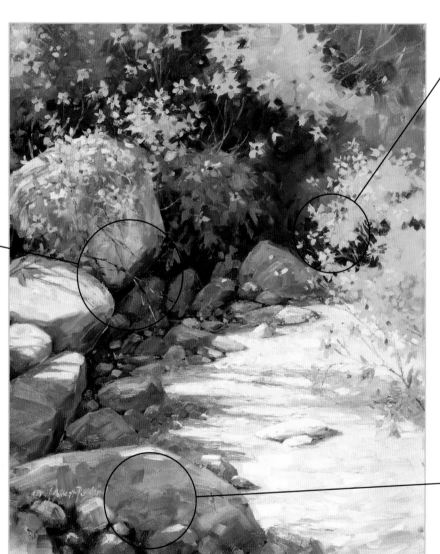

Example 1: Color as value (see page 22).

Example 3: Analogous colors (see page 24).

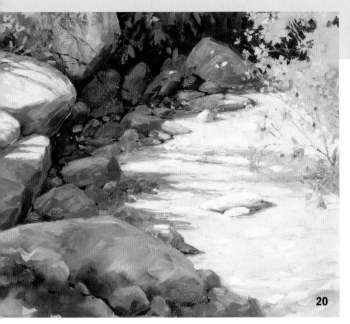

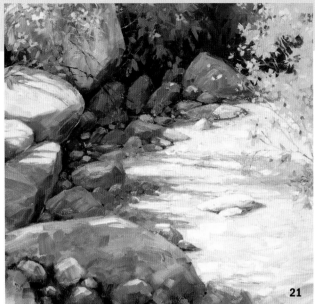

20. Flowers, Twigs and Rocks

Paint the lower left boulder with strokes of Yellow Grey, Lilac, Lavender and mixes 6, 9, 17, and 20. Run Lavender and mix 18 into the sand to create a cast shadow area in a curving counter-clockwise movement toward the left and up. This will cause the viewer's eye to travel around the bottom of the canvas and back up into the painting rather than down and out. We don't want the viewer's eye to move out, but to keep moving around within the painting.

21. Cast Shadows

Add some dark crevices in between some of the foreground rocks and some cool lights on their tops. Make sure to use mixes 18 and 19 and nothing any lighter. We want those rocks to have form but to stay in the shadows. If the tops of those rocks are painted too light they will move into the sunlight and out of the shadows.

22. Check Your Work

As I analyze the finished painting, I decide that a few more twigs sticking out over the rocks under the largest boulder might be a good idea and add to the feeling of depth. I try it—I like it!

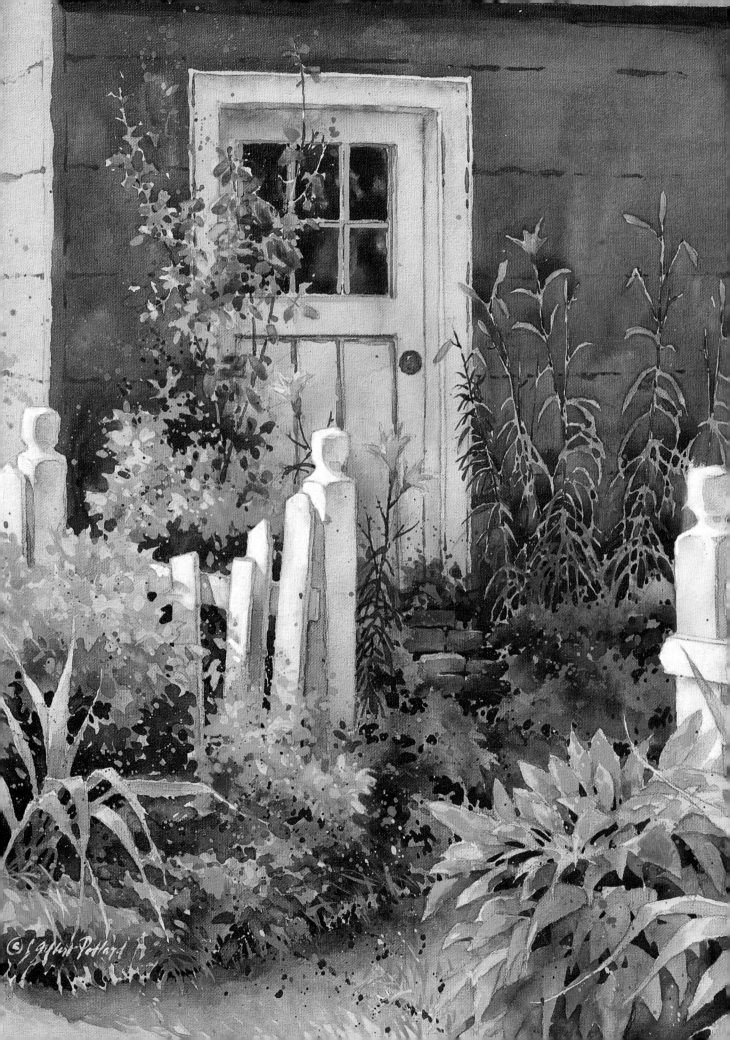

The Red Shed

While taking a pleasant stroll down the street where my husband grew up, I spotted this exquisite little gem of a photo opportunity. If you could see the scene expanded, you'd see that this is actually a very small portion of a large garage, an old structure fitted to accommodate modern usage. I am so happy that the owners had the good taste (in my view!) to retain its picturesque artistic qualities as well. You will notice when you look at the reference photo on page 63 that I deleted the motion-activated light fixture. Many artists are wonderfully successful at putting into their paintings the modern objects that reflect our times. That usually doesn't work well for me so I leave them out.

As it turned out, the owners are long-time family friends, and they enthusiastically allowed me to wander around to take pictures and gave me a tour of the old Victorian-style home—a real treat!

The Red Shed, 20 x 16 inches (51 x 41 cm), acrylics on canvas

COLOR MIX CHART

ACRYLIC COLORS USED

Place the following acrylic colors on your palette as you need them. Use a brush to create the mixes shown in the chart at right. Please note that the acrylic mixture recipes do not include the ratio of water to paint. It will be necessary to dilute the colors with water to achieve the lighter values.

White Gesso
Nickel Azo Yellow
Transparent Pyrrole Orange
Quinacridone Magenta
Permanent Violet Dark
Dioxazine Purple
Cobalt Blue
Cerulean Blue Deep
Turquois (Phthalo)

Acrylic Mixes

Mix A1
Trans. Pyrrole Orange + Quinacridone Magenta
1:1

Mix A2
Trans. Pyrrole Orange + Permanent Violet Dark + Quinacridone Magenta
1:1:1

Mix A3
Trans. Pyrrole Orange + Dioxazine Purple
5:1

Mix A4
Dioxazine Purple + Trans. Pyrrole Orange
5:1

Mix A5
Permanent Violet Dark + Cobalt Blue
1:1

Mix A6
Permanent Violet Dark + Turquois (Phthalo)
1:1

Mix A7
Dioxazine Purple + Turquois (Phthalo)
1:1

Mix A8
Dioxazine Purple + Turquois (Phthalo)
1:1

Mix A9
Cerulean Blue Deep + Quinacridone Magenta + Trans. Pyrrole Orange
1:touch:touch

Mix A10
Cerulean Blue Deep + Trans. Pyrrole Orange
1:a touch

Mix A11
Turquois (Phthalo) + Trans. Pyrrole Orange + Quinacridone Magenta
1:1:1

Mix A12
White Gesso + Turquois (Phthalo) + Trans. Pyrrole Orange + Quinacridone Magenta
5:1:1:1

Mix A13
White Gesso + Cerulean Blue Deep + Nickel Azo Yellow
7:4:1

Mix A14
Nickel Azo Yellow + Cerulean Blue Deep
1:1

Mix A15
White Gesso + Nickel Azo Yellow + Cerulean Blue Deep
9:2:1

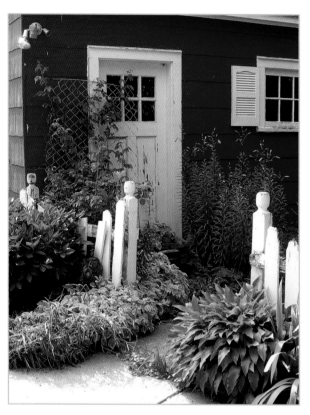

Reference Photo

This photo presents a great opportunity to study the different values of white. Intellectually, we know that the picket fence (in the sun) and the door (in shadow) were painted with the same can of white paint. So the natural tendency is to use the same color of paint for both in the painting as well—which would be wrong. Therefore, we really need to focus on value—the actual lightness or darkness of that "white" to create believable light and shade—which also produces the perception of depth in the painting.

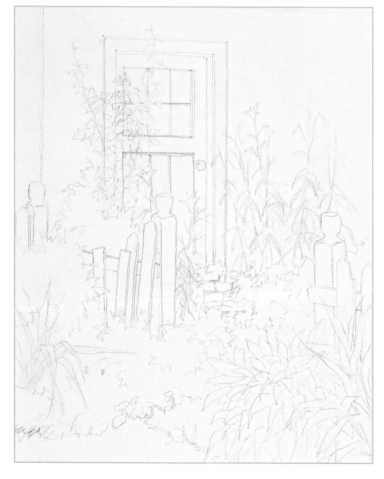

Begin With the Drawing

Loosely draw or transfer the composition onto the canvas using a soft pencil. A traceable line drawing for this painting is available on page 138.

PAINT ENTIRELY WITH FLUID ACRYLICS

1. Darkest Shapes

Using your acrylics transparently, first paint the darkest accents. Resist with all your might the urge to make the window shapes too perfect! The painting will have much more personality and character if you avoid rigidly drawn shapes. Use various combinations of Dioxazine Purple and Turquois (Phthalo) (mixes A7 and A8—mix A8 shows the two colors thoroughly mixed while A7 shows the two colors separate on the sides and mixing in the middle) with mere touches of Nickel Azo Yellow here and there. For example, flick a few spots of Nickel Azo Yellow into the top middle, upper right and lower right wet window panes to suggest leaf reflections.

Note that all the dark shapes in the foliage in this step are negative shapes. The window panes are positive shapes—however, since you are painting around the window spacer bars and around the roses and leaves, you are painting in a negative painting manner.

2. Remaining Shapes and Left Side Wall

Continue painting the dark accent shapes, now adding some rose bush canes and stems and leaves to the tiger lilies. Again, note that these are positive shapes where the darks you painted in step one were mostly negative shapes.

The underlying structure of the painting is now in place.

Using mix A1, establish the light, left side of the building. Allow the color to overlap the corner of the building—soften the right edge of the wash with clear water to prevent a hard edge to the color.

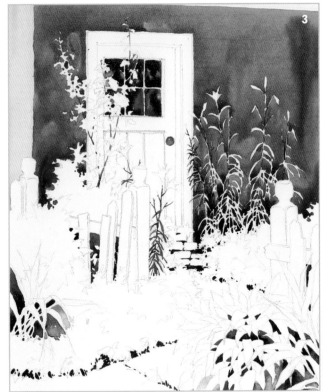

3. Red Wall

Using mix A2, paint the wall, painting around the flowers, leaves and door. Keep the paint wet as you go up and around the top of the door and down the other side. Do *not* homogenize your mixture—allow some variegation (as shown in the color swatch on page 62) for more eye entertainment. A dark wet-in-wet stroke of mix A3 in the upper right (see where I allowed it to run down?) will coax the viewer's eye back into the painting.

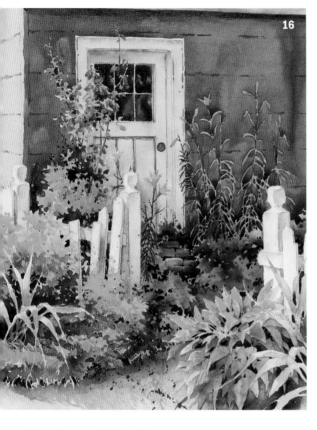

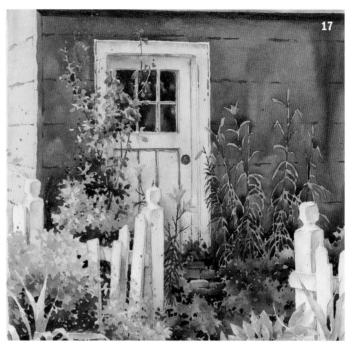

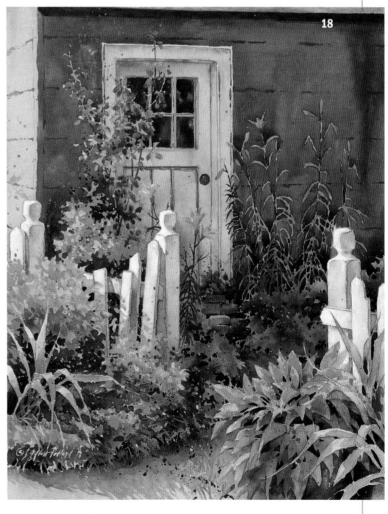

16. Foliage and Sidewalk

Add white gesso to some Cerulean Blue Deep and Nickel Azo Yellow to make three opaque greens (mixes A12, A13 and A15) and "beef up" the foliage here and there where needed. Splatter a bit of the same mixture over some of the dark areas of the foliage to break up the darks a little. Refer to the photo above for placement.

Splatter some very dark purple over the sidewalk in the shadow area to add texture and interest.

17. Opaque Leaves and Wall Splatters

Add some more opaque leaves and use the same opaque pale green to splatter on the wall just above the shrubbery. This splatter will visually balance with the splatter on the sidewalk and shrubbery.

18. Check Your Work

Step back and take a good look at your painting to see if it needs any final adjustments. I decided to add some pure white gesso highlights on the tops and sides of the parts of the fence and posts that are receiving the most direct sunlight. This will be a little more striking than the white canvas alone. Compare the fence and posts in this step to the previous few steps and you'll see the difference this makes—the "whiter white" of the added gesso causes the fence posts to come forward even more than before.

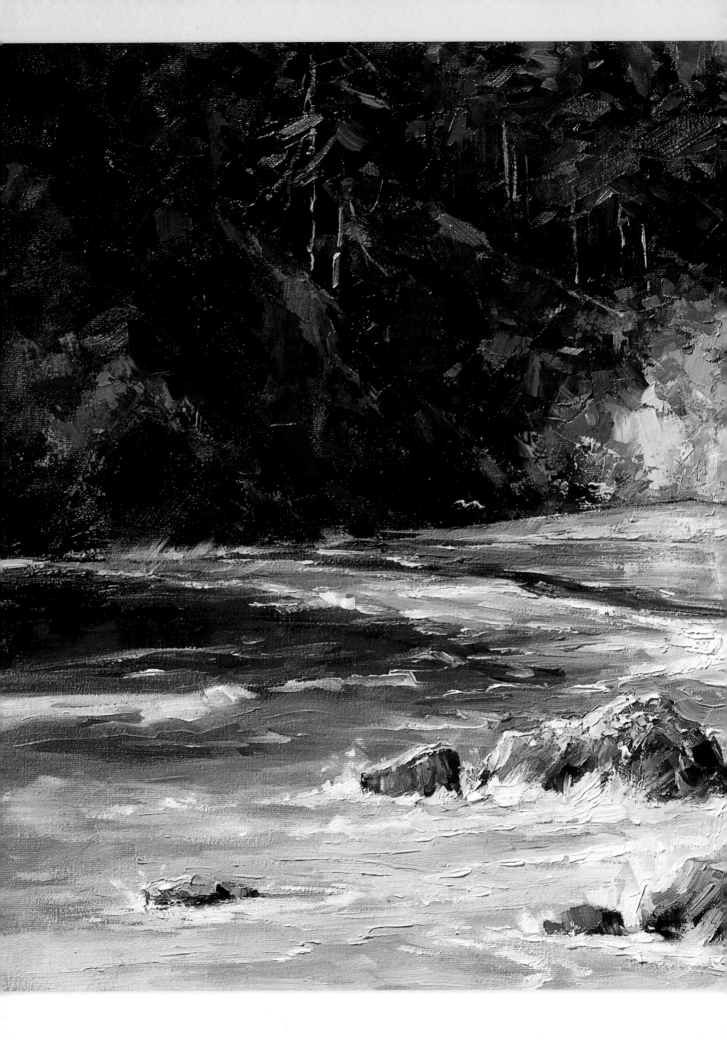

Color Lesson #5: USE BLUES AND GREENS TO PORTRAY DEEP AND SHALLOW WATER

Ecola Cove is a study in the amazing variety of colors you can use to depict water in all its forms, from the rich, dark blues of the deep ocean to the light greens and sand colors you can see in the clear shallow water that rolls up onto a beach.

There is also a wide range of color in the sand itself, depending on whether the sand is dry or wet, or if it is under a shallow layer of water. *Ecola Cove* began with an orange underpainting, and you can see that orange color peeking through many areas of the sandy

beach and in the rocks and land masses in the foreground and background.

To help you sort out the rich variety of blues, greens and sand colors used in this painting, I've placed some swatches of the tube oil colors and color mixes from the chart on page 72 next to the painting below. Don't be afraid to use lots of colors when you paint a water scene—that's what nature does!

WATER COLORS

Mix 7

Blue Grey

Cobalt Green

Green Blue

Mix 4

Mix 6

Cream

SAND COLORS

Mix 13

Mix 10

Mix 2

Mix 12

Mix 1

Mix 9

Yellow Grey

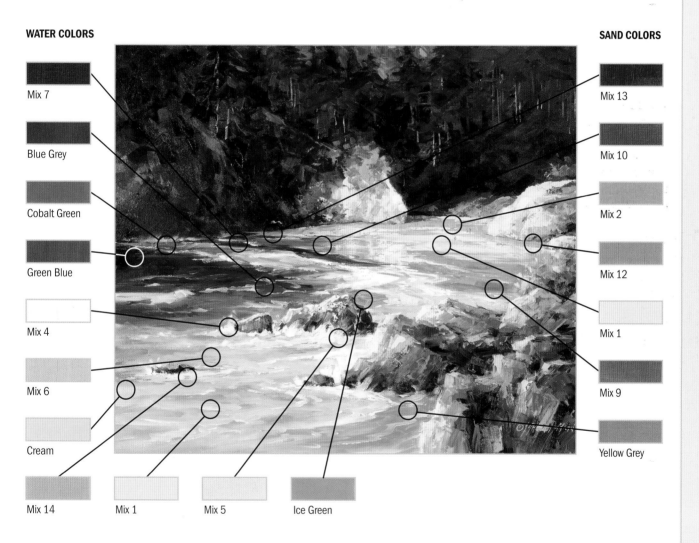

Mix 14

Mix 1

Mix 5

Ice Green

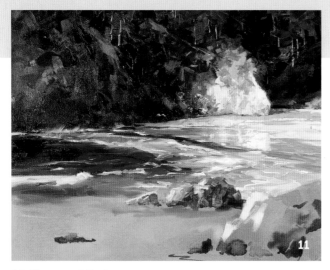

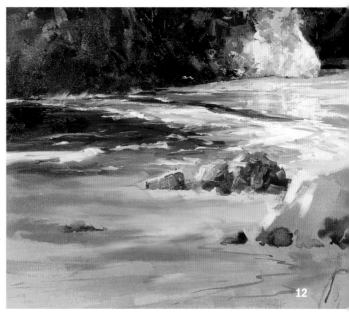

11. Waves and Rocks

To depict the crescent shape of the cove, direct the shapes of the waves around in an elliptical clockwise movement.

Begin painting the rocks in the waves using the cliff and sand colors you've used so far. Don't neglect the water to the right of those rocks—use light sand colors and touches of Ice Green.

12. Foreground Water

Add some color mixes 1, 5 and 6 to the foamy water to the right of those same rocks. Add a bit of mix 14 to the water at the base of those rocks.

Pull the water colors Yellow Grey, Cobalt Green, some Ice Green and Cream down into the foreground to form a base for the wave action we'll be working on in steps 14 and 15.

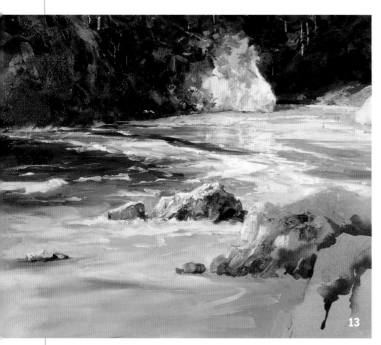

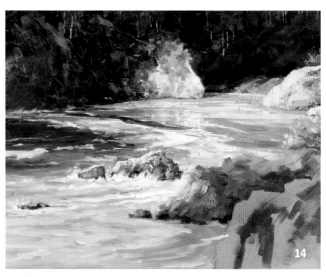

13. Foreground Water and Rocks

Add more of the same to the foreground water using more Yellow Grey and some mix 1 so that the viewer has the sense of seeing the sand under the water. This will make the water appear clear and shallow in this area. Use Orange Grey and Purple Lake to begin painting the little rock sitting all by its lonesome out in the water.

Throw a few strokes of color and texture onto the rock mass at right just to get it started.

Use wavy strokes to suggest the motion of the water as it moves around the foreground rocks and add some more strokes to the rocks themselves.

14. Wave Action and Spray

With mix 5, splash some spray up onto the rocks as shown. Merge the splashes into the wave action. Save the lightest color—mix 4—for the very lightest accents on the waves.

Use wavy strokes of mixes 1 and 6 to indicate swirling water. Don't cover up all the sand underneath, though!

Work a bit more on the rocks to the right.

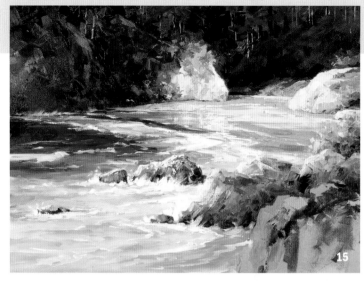

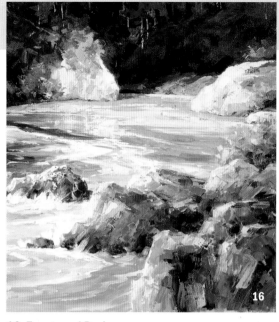

15. Wave Edges and Rock Colors

Now add strokes of mix 1 to the edges of the receding wavelets in the foreground. Again, save mix 4 for the very lightest touches.

Bring some spray up over the dark base of the rocks jutting partway into the shallow water using the brush technique shown in step 10.

Begin the process of refining the rocks. Continue to use Green Grey, Purple Lake, and mixes 3, 7, 10, 12 and 13, and use the lighter colors of Jaune Brillant and mixes 1 and 11 on the edges facing the sun.

16. Foreground Rocks

Continue refining the rocks. Pay close attention to the planes of those rocks. A palette knife works well for describing the planes and angles of a rockface.

Use the same colors and techniques to finish the rocks closest to the viewer in the lower right corner of the canvas.

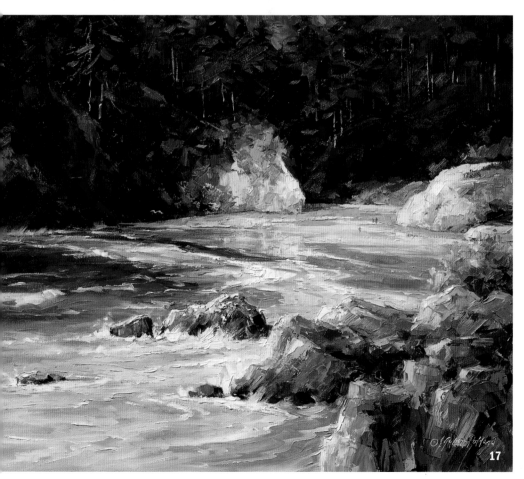

17. Check Your Work

Take a final look at your entire painting to see if there are any areas that could be improved. I made two minor adjustments to the foreground rock mass: I adjusted the edges of some of the rocks to make them less rounded and more angular—you should be able to spot them. Of that group of rocks, I also added brushstrokes of Lavender and mix 14 to the top plane of the middle rock which suggests blue sky reflecting into a wet rock surface.

La Siesta del Gato

A hot August day in Santa Fe. What better way to express that idea than a cat dozing in some precious shade and giving it a Spanish title? "La Siesta del Gato" translates loosely to "cat nap." Simon the cat wasn't with me on that trip but I had a picture of him taking a cat nap in my living room at home, and the orientation of him on the table was just about the same as if he had actually been lying on the warm rock wall. When combining reference photos for your paintings, it's so helpful to find ones that actually work together. If you have to change or make up too much stuff to get the two photos to fit, it may be more trouble than it's worth!

La Siesta del Gato, 16 x 20 inches (41 x 51 cm), oils over acrylic on canvas

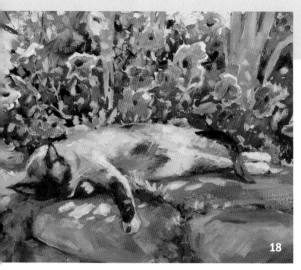

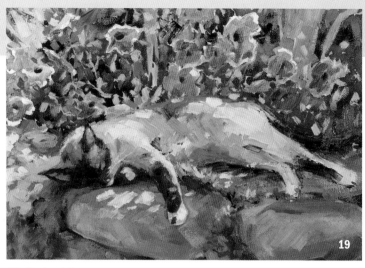

18. Cat

Then I added a tail draped across his legs. This actually didn't look too bad. However, now I was on a true mission to create a great looking cat, not just an OK cat. So I threw caution to the wind and began painting spontaneously the cat you now see in the finished painting below.

19. Revised Cat

After spending a lot of time studying photos of cats in similar positions, I settled on this pose. I scraped the paint off of the offending areas and re-painted the bulk of the body with medium value Yellow Grey. I also repainted the background of flowers, foliage and rock around the new cat shape to create the new body contour. I then proceeded to model the body by darkening the belly with Orange Grey, and used Purple Lake for the dark markings and to separate the legs. On the darker fur over his ribs I allowed the Purple Lake to mix with the underlying Yellow Grey so it is not too dark. I used mix 4 for the sun-splashes on the top of his head and arm, his shoulder, back, haunch and feet. I laid the light value over the darker paint underneath as if I were "frosting a cake" to keep the layers from mixing together.

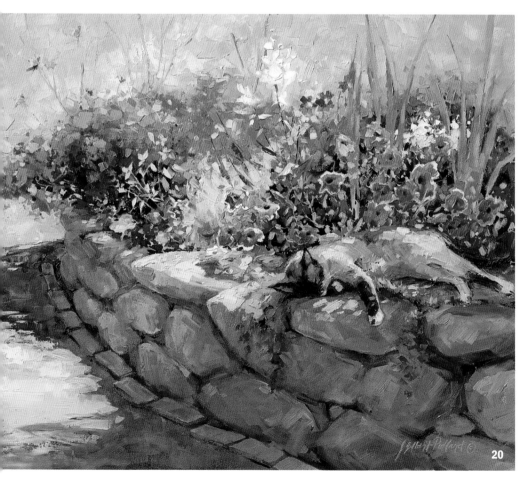

20. Check Your Work

So—here's the final version of the painting. There must be a lesson here somewhere. The one that springs to mind is paint it 'til you get it right. Something you will hear quite often is that a painting looks "overworked." And it's true that a painting can become muddy and unattractive when worked on for a long time, especially if during that time the painter is unable to accomplish the desired objective! But I think the word "overworked" is definitely overused. By working over a problem area of a painting, you can correct and freshen if you do it right. It just takes practice. You won't get that practice if you fear overworking. You must be willing to make a lot of messes in your painting career in order to become a practiced and confident painter.

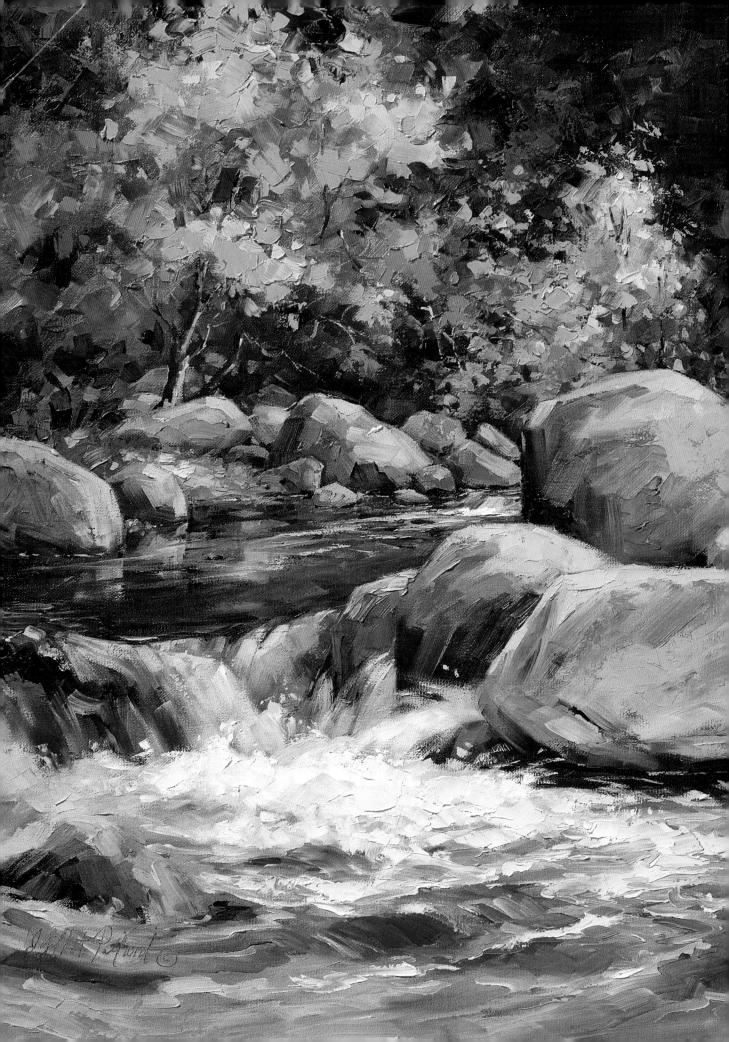

Twilight on the Creek

I spend at least a week every year in Oak Creek Canyon above Sedona, Arizona, and this is one of my favorite spots along the creek. I love to poke around among the rocks, take pictures, paint "en plein air" and just sit and listen to the music of the water. I have sat for many hours—often with pencil or brush in hand—staring at the action of the water as it runs swiftly and smoothly, then cascades, then splashes and burbles into decreasing concentric circles, internalizing this movement until I not only see it but feel it. The experts usually tell us to paint what we know. A complex subject such as this demands this intimate familiarity. Spending time with a musical creek is also balm to the soul!

Twilight on the Creek, 20 x 16 inches (51 x 41 cm), oils over acrylic on canvas

COLOR MIX CHARTS

ACRYLIC COLORS USED

Place the following acrylic colors on your palette as you need them. Use a brush to create the mixes shown in the chart at right. Thin to transparency with water as required in the instructions on the upcoming pages.

Transparent Pyrrole Orange
Dioxazine Purple

Acrylic Mixes

Mix A1
Trans. Pyrrole Orange
+ Dioxazine Purple
1:1

Mix A2
Trans. Pyrrole Orange
+ Dioxazine Purple
1:1

OIL COLORS USED

Place the following tube oil colors on your palette. Use a palette knife to create the mixes shown in the chart at right.

Titanium White
Cream
Marigold
Yellow Grey
Caramel
Deep Yellow
Jaune Brillant
Orange
Rose Grey
Purple Lake
Light Magenta
Rose Violet
Mauve
Lilac
Lavender
Blue Grey
Prussian Green
Cobalt Green
Green Grey

Oil Color Mixes

Mix 1
White + Lavender
+ Orange
3:1:a touch

Mix 2
Lavender + White
+ Orange
3:1:a touch

Mix 3
Yellow Grey +
Lilac
1:1

Mix 4
Lilac + Rose
Violet
2:1

Mix 5
Yellow Grey +
Orange + Rose
Violet + Mauve
6:1:1:1

Mix 6
Rose Grey + Light
Magenta + Rose
Violet
1:1:1

Mix 7
Lilac + Mauve
1:1

Mix 8
Jaune Brillant +
Mauve
1:1

Mix 9
White + Lavender
1:a touch

Mix 10
White + Blue
Grey
1:a touch

Mix 11
Cream + Marigold + Lilac
2:1:1

Mix 12
Cream + Yellow
Grey + Marigold
3:2:1

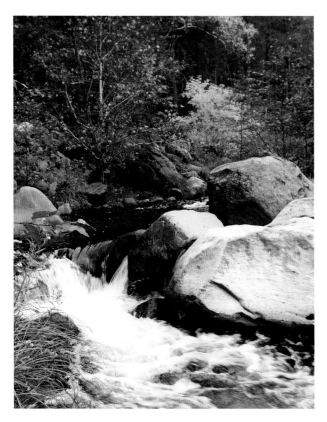

Reference Photo

This was taken in Oak Creek Canyon on a late afternoon in November. The sky was luminous as the sun was still shining somewhere beyond the canyon walls, giving me enough light to take pictures and then make it the half mile back to the cabin before dark. But the canyon itself would get no more direct sun that day and it was getting pretty chilly. I usually paint in full sun and shadow, so painting this ambience was a departure for me.

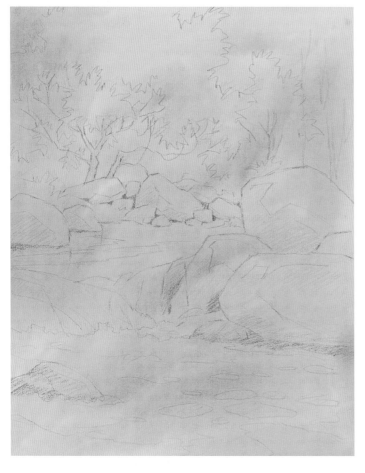

Tone the Canvas and Transfer the Drawing

Tone the canvas with diluted washes of Transparent Pyrrole Orange. You can wet the canvas first with clear water if you want a smoother and wet-into-wet look. Let dry.

Draw or transfer the drawing onto the toned canvas. A traceable line drawing for this painting is available on page 140.

BEGIN WITH AN ACRYLIC UNDER-PAINTING

1. Shadowed Areas

Acrylic colors Transparent Pyrrole Orange and Dioxazine Purple, when mixed, produce a color very similar to the oil color, Purple Lake. Use this mix A1 and a more diluted version, mix A2 (see the acrylic color chart on page 92), to paint a monochromatic under-painting that will map out the shapes and many of the correct values for the finished painting.

Begin by painting some of the spaces between the rocks just under the tree and the darker waterline of those rocks. Then drop down to the boulders in the foreground and darken parts of the lower left rock, the recess under the boulder at far right and parts of adjacent rocks as shown here.

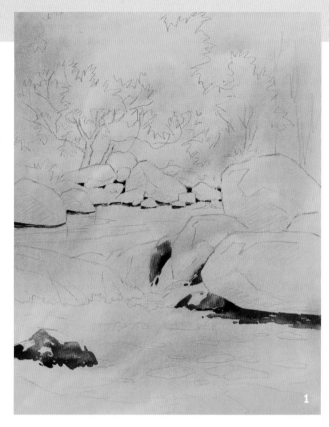

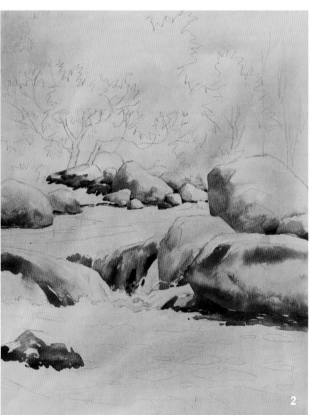

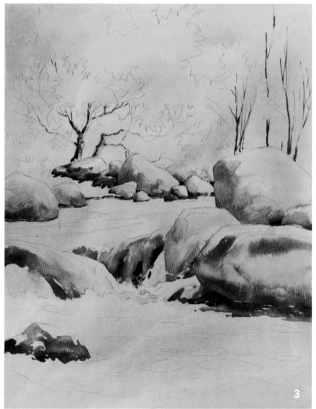

2. Rocks, Boulders and Flowing Water

Using the same two acrylic mixes, continue modeling the shapes of the rocks and boulders, and the water where it flows over unseen rocks.

3. Tree Trunks

Paint the main tree trunks, keeping them lighter on the right side because of the direction of the light source. The slender tree trunks to the right behind the largest boulders are too spindly to warrant this kind of attention—just paint them flat.

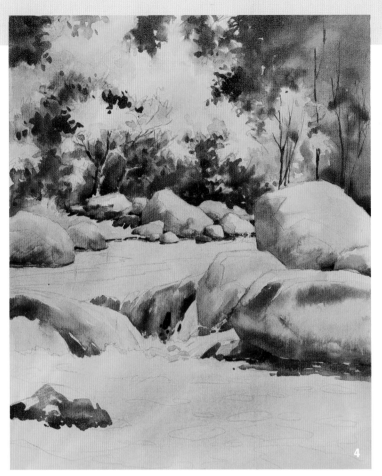

4. Dark Background

Loosely paint the background around the large foliage area to really push that background back into the woods. Slightly darken the interior of the tree foliage, going around the clumps of leaves that are in front of the trunk. Notice how each step gives the painting more depth.

5. Water Movement

Study the movement of the water in the background for a moment, then paint, with your brushstrokes moving to the rhythm of the water. Try to feel that serene current. Do the same with the choppier texture of the water after it has fallen to the lower level in the foreground. Feel the agitation of the water in that area. Sometimes it is helpful to imagine a leaf floating down the creek—picture the movements of that leaf as it travels down the quiet, smooth water; then plummets; then bounces around in the rapids and comes out of that turmoil and down the quieter stream once again. The successful drawing and painting of water in motion requires internalizing the visual information of that action and energy.

Now, look at what you have accomplished with just two colors: The whole picture is there—just waiting for some beautiful color and texture to be added with oils.

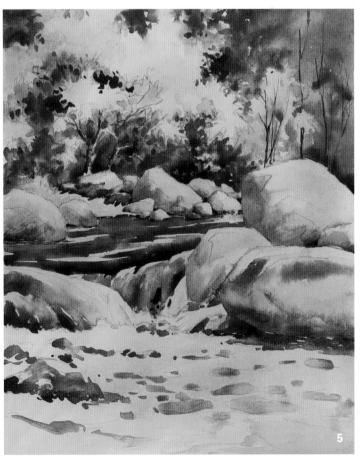

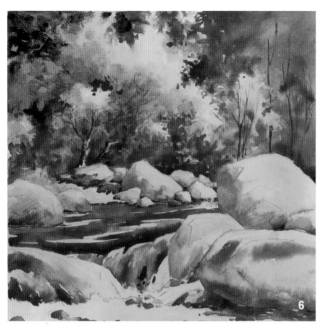

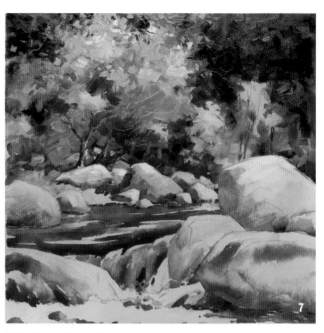

6. Tree Foliage

Scrub first Mauve, then Rose Violet transparently to add richer color to the foliage.

Working on the upper left corner, brush in dark Prussian Green and purple mix 7, then Deep Yellow (which actually looks very orange) and mix 5 to begin painting the fall foliage.

7. Rocks and Tree Canopy

Start painting the rocks in the top half of the painting using Yellow Grey, Rose Grey, Purple Lake, Lavender, and oil mixes 1, 3, 5 and 7.

Carry on painting the tree canopy, using purples in the out-of-light areas and continuing the dark background to the right side of the tree. Scrape some branches out of the foliage with the tip of a palette knife.

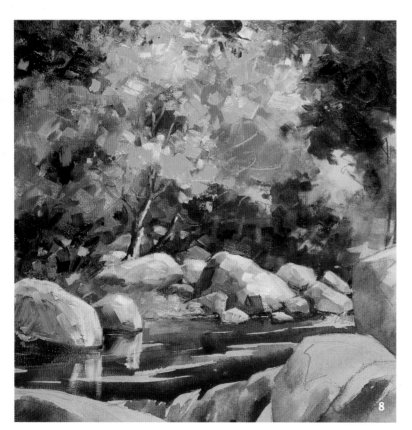

8. Rocks and Reflections

Paint in some branches and twigs with Lavender. Paint the light side of both large and smaller tree trunks with Jaune Brillant.

As you develop the rock shapes, pull some of the same rock color down into its reflection in the water using vertical brush strokes. Note that reflections are mirrored directly under the object that is being reflected.

Also notice that the rocks are darker where the water has lapped up against them just above the waterline—use Purple Lake for these areas. That dark is often reflected into the water as well. Additionally, where the water meets the rock, it curves up ever so slightly against the rock and that curve forms a sliver of a plane that reflects light back into the viewer's eye, so paint a fine, broken line of light at water's edge with oil mix 1.

These three aspects—reflections, a darker band of color above the waterline, and a fine line of reflected light—do wonders in capturing the look of water.

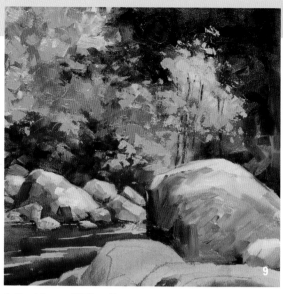

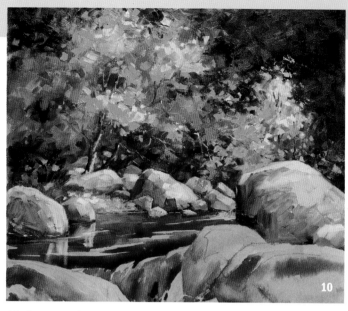

9. Boulder and Yellow Tree

Being conscious of the light and dark planes of the boulder on the far right, paint them with appropriate values of Caramel, Rose Grey, Purple Lake, Lavender, Cobalt Green, Green Grey, and mixes 1, 2 and 4. Allow some of your colors, such as Rose Grey and Lavender, to mix on the canvas to make a dark gray. Begin to flesh out the small yellow tree above that far right boulder using Deep Yellow, Yellow Grey, and mixes 3, 5 and 12.

10. Orange Leaves

Paint the orange leaves in front of the yellow tree and over some of the rocks, thereby pushing the smaller tree and the rocks back—more depth in the painting! Add some more twigs using a combination of painting with Purple Lake and Orange Grey and more scraping if needed.

Add lighter colors of Cream and Jaune Brillant to the sides of the trees that are in brighter light.

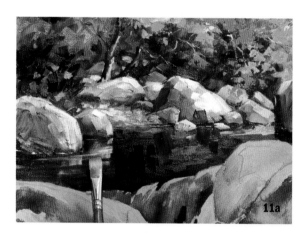

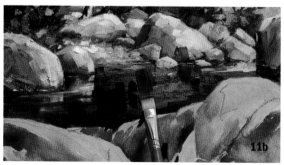

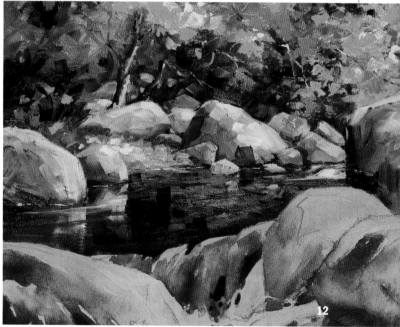

11. Rock Reflections

Begin developing the reflective quality of the water by pulling the colors of the rocks down into the reflections. In order to make water look wet and reflective, a combination of horizontal (top) and vertical (bottom) brushstrokes is needed.

12. Small Creek and Whitewater

Add more reflected color as needed. Surround the small whitewater area with Prussian Green. Begin painting the small area of creek leading to the whitewater with Blue Grey and touches of mix 1, allowing your brush to imitate the flow of the water, especially where the water falls down to the bubbly area.

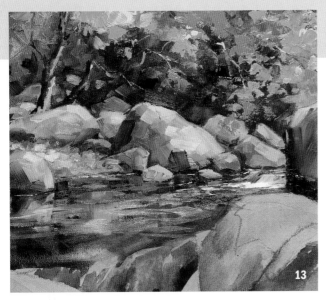

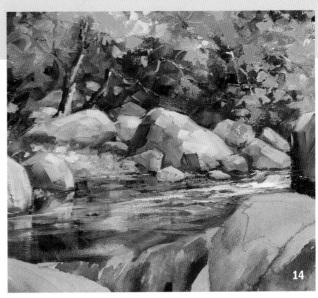

13. Whitewater and Orange Reflection

Now paint the whitewater itself, using mix 9, not pure white! Coming forward in the creek, paint the orange reflection of the tree above the water using Deep Yellow.

14. Rippling Water

Extend little ripples of whitewater over the orange reflection.

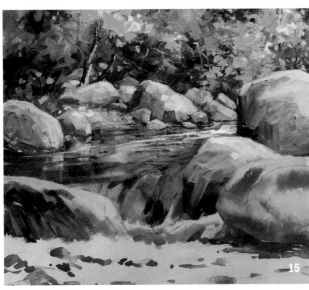

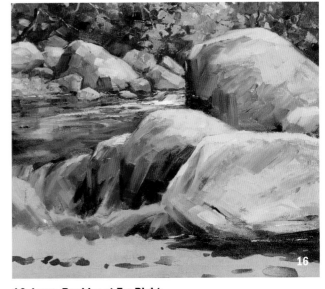

15. Boulder, Rock and Waterfall

Paint the boulder and rock just to the right and left of the main waterfall using Yellow Grey, Lavender, Blue Grey, Prussian Green, Green Grey, Purple Lake, and mixes 1, 3, 5, 6, 7 and 8. Use diagonal downward strokes to begin the waterfall itself, using the same colors.

16. Large Boulder at Far Right

Begin working on the large boulder at far right, taking care to remember the direction of the light source. Paint the dark water under that boulder with Purple Lake, then use the chisel edge of your brush with mix 9 to create a water line.

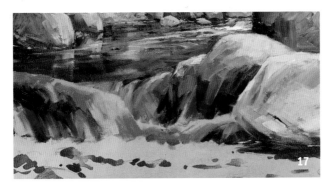

17. Boulder at Left of Waterfall

Apply more color to the boulder at far left that is hidden by the water that is cascading over it. You're actually painting the water here; the way you shape it will indicate that there is a boulder just under the flow of the water.

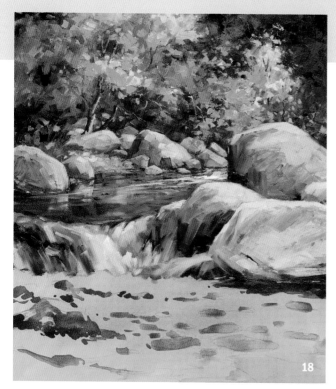

18. Waterfall

Notice how the water is plunging into that central area from several directions? Paint the splashes that occur there. For the darker water, use Blue Grey, Cobalt Green and touches of mix 7. For the lighter, use mixes 1, 2 and 10, plus a bit of Lilac.

19. Waterfall

Paint the lighter values of the water that is gushing into the central pool from between the rocks on the right, using mixes 1 and 2. Move your brush in the same direction the water flows.

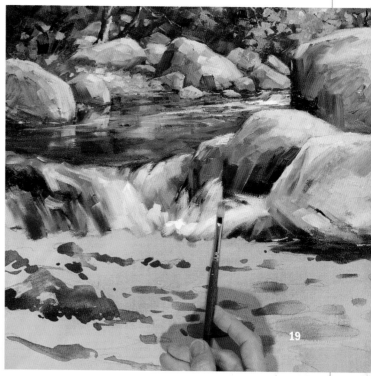

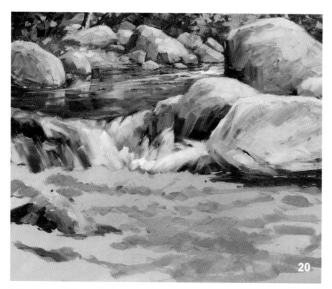

20. Choppy Water in Foreground

Following the acrylic under-painting, use choppy strokes over the "dips" in the foreground water using Green Grey.

Start painting the small wet rock on the left, using dark colors—Purple Lake, Green Grey and mix 7—on the left, out-of-light side and Deep Yellow and Jaune Brillant on the top and right side to reflect the autumn color of the tree above. Also use some Lavender and mixes 2 and 3 to keep it lively and not a solid orange.

21. Choppy Water and Splashes

Add to the undulating water that is forward of the whitewater with darker values of Blue Grey inside—not completely covering the earlier strokes of Green Grey. Using mix 2, add strokes that will provide a base for the whitewater to come.

Using mixes 1 and 9, bring in some water splashes from the left.

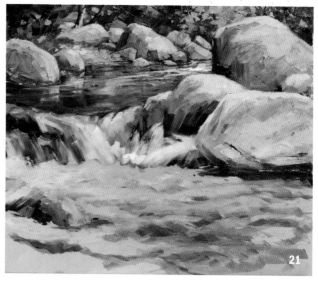

Color Lesson #7: PAINT MOVING WATER USING VALUES AND EXPRESSIVE BRUSHWORK

When you look closely at the painting in this demonstration, *Twilight on the Creek*, you can see many different aspects of water as it flows downstream through a rocky creek bed and over a small waterfall. In the background, the water moves slowly and serenely along tree-lined banks, and the calm water reflects the colors of the rocks and foliage above it. Then it suddenly cascades over a small waterfall, creating whitewater and foam as air bubbles mix with the active water. The fast-moving water causes small waves and choppiness in the foreground as the creek comes toward the viewer.

So how do you portray all these different aspects of water in one painting? First, choose colors in appropriate values to differenti-ate between calm reflective water, cascading water, and very active whitewater. Second, use expressive movement in your brushwork to make the water come to life.

In this lesson, we'll look at some of the colors and values that were used for the water and rocks in *Twilight on the Creek*. Refer to the color charts on page 92 for the mixes. You'll notice that some of the same colors were used for both; that's because the colors of the rocks are often reflected in the water!

ROCK COLORS

Deep Yellow Mix 6 Mix 7 Mix 1 Mix 4 Mix 2 Green Grey Lavender

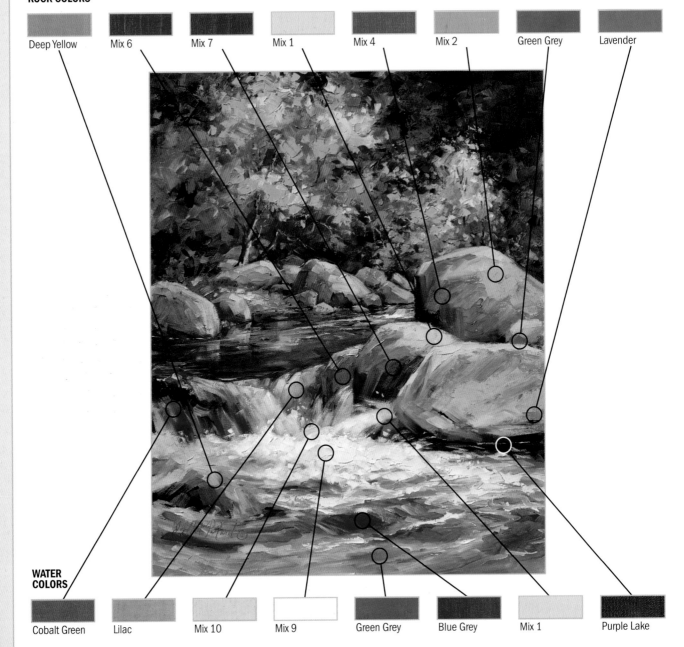

WATER COLORS

Cobalt Green Lilac Mix 10 Mix 9 Green Grey Blue Grey Mix 1 Purple Lake

22. Whitewater

With mixes 9 and 10, paint the whitewater below the waterfall using choppy strokes. Add a few touches of whitewater splashes against the darker rock and water to really produce a frothy look. The very last step on the whitewater is to add—very sparingly—touches of pure white anywhere you want a little extra sparkle.

23. Reflections and Bubbles

Add some Lilac to the water on the right to create a hint of reflection from the boulder above. The water has too much movement here to show much reflection. Also, begin painting some gestural strokes to suggest the concentric circles of bubbles that fan out from the area of whitewater.

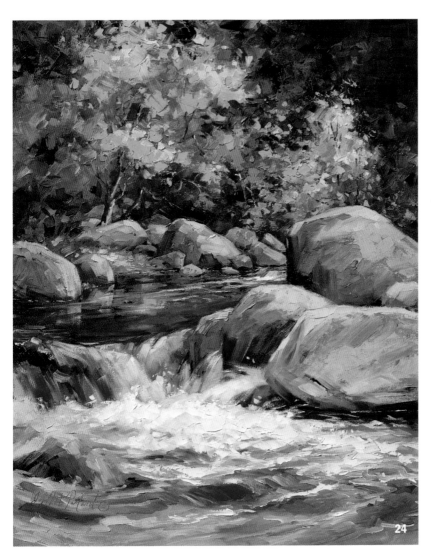

24. Check Your Work

Take a final look at your entire painting to see if there are any areas that can be improved. I decided to refine the foreground water with strokes that reflect the movement of the water as it swirls towards the viewer. Notice the almost scalloped brushstrokes that add a little more "swirl" to the water. I used mix 9 for this—pure white would take too much attention away from the waterfall area.

Butchart Gardens Gem

Here we are again at Canada's lovely Butchart Gardens in Victoria, British Columbia. The first time I painted this scene I was sitting on a bench under the tree whose branch you see at top left. We had taken the whole magnificent tour, I had carried my portable painting equipment around on my back for several hours and I was bound and determined to have a "plein air experience"! The small watercolor sketch I was able to produce wasn't much to look at but the experience was invaluable.

If you want to become a good painter you must paint—and then paint some more. You must put a lot of mileage on your brush. Try not to be upset when your paintings fall short of your mental image of how you hope they will turn out—mine always do fall short. Remember that your skills have to catch up with your vision—and that our personal vision is the prize that makes us persevere!

Butchart Gardens Gem, 20 x 16 inches (51 x 41 cm), oils over acrylic on canvas

COLOR MIX CHARTS

ACRYLIC COLORS USED

Place the following acrylic colors on your palette as you need them. Use a brush to create the mixes shown in the chart at right. Thin to transparency as required in the instructions on the upcoming pages.

Pyrrole Orange
Dioxazine Purple

Acrylic Mixes

Mix A1
Pyrrole Orange +
Dioxazine Purple
1:1

Mix A2
Pyrrole Orange +
Dioxazine Purple
1:1

OIL COLORS USED

Place the following tube oil colors on your palette. Use a palette knife to create the mixes shown in the chart at right.

Titanium White
Lemon
Cream
Yellow Grey
Orange Grey
Caramel
Yellow
Deep Yellow
Jaune Brillant
Orange
Cadmium Red Hue
Rose Grey
Purple Lake
Light Magenta
Rose Violet
Mauve
Lilac
Lavender
Blue Grey
Prussian Green
Cobalt Green
Ice Green
Green Grey
Yellow Green
Leaf Green

Oil Color Mixes

Mix 1
White + Cream +
Jaune Brillant
3:1:1

Mix 2
White + Cream +
Jaune Brillant +
Light Magenta
6:3:1:1

Mix 3
Jaune Brillant +
Light Magenta +
Lilac
3:2:1

Mix 4
Rose Grey + Light
Magenta
1:1

Mix 5
Rose Violet +
Cadmium Red
Hue
1:1

Mix 6
Light Magenta +
Rose Violet
2:1

Mix 7
Mauve + Light
Magenta
1:1

Mix 8
White + Leaf
Green
4:1

Mix 9
Leaf Green +
White
3:1

Mix 10
Leaf Green +
White + Green
Grey
4:2:1

Mix 11
White + Yellow
Green
3:1

Mix 12
Yellow Green +
White
3:1

Mix 13
Leaf Green +
Cobalt Green +
Lavender
2:1:1

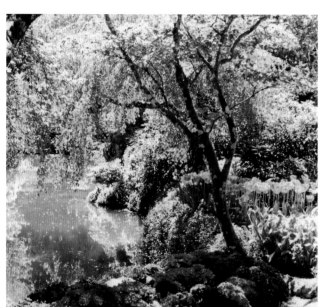

Reference Photos

In another instance of photo combining, I chose a picture of ducks I had taken in a nearby park in Victoria. Luckily, the water is the same color and the photo was taken close to the same time of day with the sun filtering through the foliage. The photos work well together. Of the five ducks in the photo, I chose three for the painting that I felt made an attractive grouping.

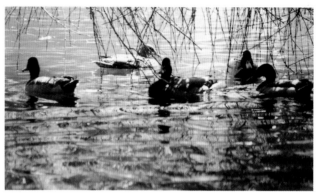

Tone the Canvas and Transfer the Drawing

Tone the canvas with Pyrrole Orange and allow to dry. Draw or transfer the drawing onto the toned canvas. A traceable line drawing for this painting is available on page 141.

1. Darkest Shapes

With acrylic mixes A1 and A2, begin by painting the tree trunks, branches and twigs, then the dark parts of the ducks and the negative dark shapes between the various plant shapes and rocks in the plant edging.

When I tell you to paint the "negative shapes" I simply mean to paint around the positive shapes. Take a look at the tulip bed. The stems and flowers are "positive" shapes—the dark spaces between and around them are so-called "negative" shapes. If you look at step 4 on the facing page, you will see that I painted the light yellow-green background around the branch and twigs. That is "negative painting" with light color rather than dark. So remember that "negative painting" merely refers to painting around shapes.

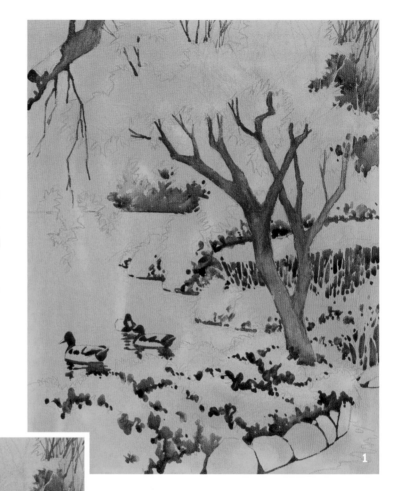

2. Cast Shadows, Reflections and Plant Forms

Use mix A2 to give the bushes and trees a bit more depth than was achieved with just the darker accent shapes in step 1. This is easiest to see in the bush mass above the bed of tulips. I also used mix A2 to establish reflections in the water and the shadows cast by the tree at lower right.

The composition is now locked in—time to bring out the oils!

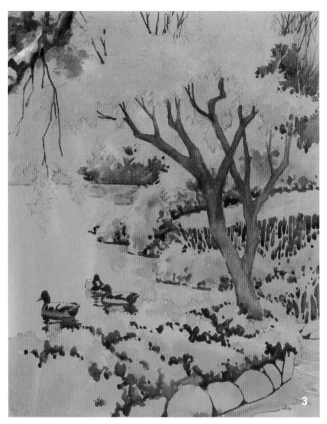

3. Tree Foliage and Branch

With Caramel, Rose Grey, Blue Grey, Cobalt Green and Green Grey, begin in the upper left corner to "smear in" some tree foliage. Then with Jaune Brillant, Purple Lake, Lavender and oil mix 7, paint the large branch in the upper left.

4. Tree Foliage

Apply oil mixes 8 and 11 over parts of the previously painted foliage area as shown. Some mixing will take place between the two layers. This is called "wet into wet" and produces desirable results when you learn to control the mixing that occurs. Continuing with mixes 8 and 11, paint across the top, not covering up the twigs but painting around them. Add mixes 2 and 3, plus Lilac, to the pink foliage.

5. Pink Flowering Tree

Continue in the same manner and with the same colors, adding mix 4 for the darker areas, and work your way down into the large foliage clump of the pink tree.

6. Pink Flowering Tree

Add some Lilac and Lavender to the shadowy areas of the same foliage, then use mix 1 for the lightest and topmost leaves to indicate that the sun is hitting the tree from high in the sky. Add mixes 9 and 10 to your greens.

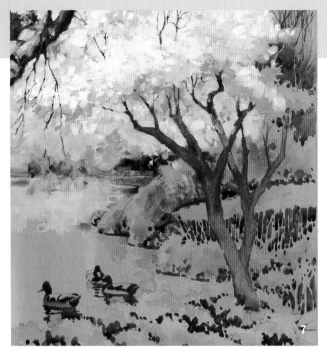

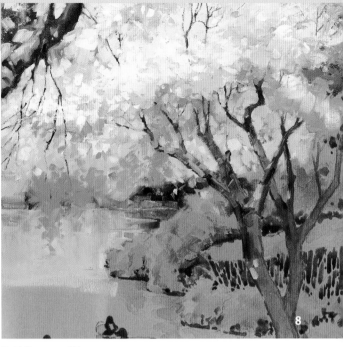

7. Background Foliage and Water Reflections

Work into the background beneath and behind the pink tree canopy with the same cool colors plus Ice Green and mixes 10 and 7. Begin defining some of the branches. Darken the deepest area with Prussian Green with Blue Grey directly beneath. Then pull a Blue Grey reflection down into the water, also with Blue Grey. Create a water line with the chisel edge of your brush and mix 10.

Pull down reflections of colors into the water to the left as well. Add a leaf or two over the darkest area just above the waterline.

8. Foliage and Tree

Work into the upper right foliage and twig area, using the same colors and methods, following the acrylic pattern already laid out.

Bring the water down closer to the foreground. Further define the trunk, branches and twigs of the pink tree as you go. Use a variety of colors that you have already used. Pure Lilac is used for the sun spots.

Jump over to the left side and begin painting the leafy branches that are hanging down over the water using mix 13. Begin painting the bushes to the right of the water also with mix 13.

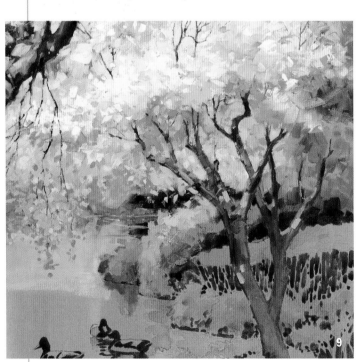

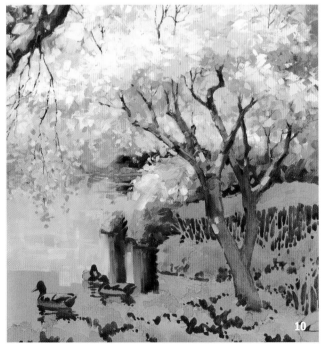

9. Leaves and Background

Add lighter value leaf shapes to the hanging branches and some lighter colors to the top of the bushes behind the pink tree. Add mix 12 to your greens. Work on the right side of the pink tree and the background down to the top of the mass of orange tulips.

10. Pink Tree, Bush and Water

Define the pink foliage and the bush a bit more. Paint the water on the left farther down, then paint some reflection color and value down into the water under the bush—the water and reflections must be painted down to the top and around the sides of the ducks' heads and bodies.

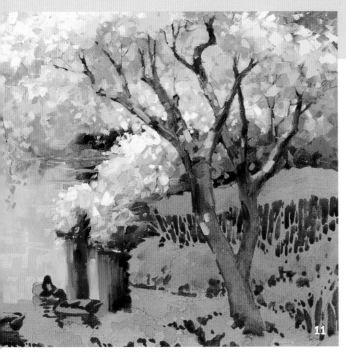

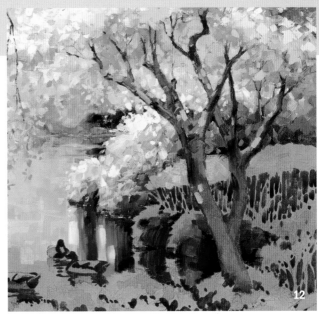

11. Bush

With mix 8, add some very light leaves to the top of the bush shapes to indicate where the sunlight is hitting the strongest.

12. Orange Tulips

Using Deep Yellow and Orange, start painting the mass of orange tulips starting to the left of the pink tree trunk. Paint in a dark basecoat on the bushes directly under the orange tulips using Mauve, Blue Grey and Prussian Green. Add lighter reflection strokes under the green bushes using mix 11.

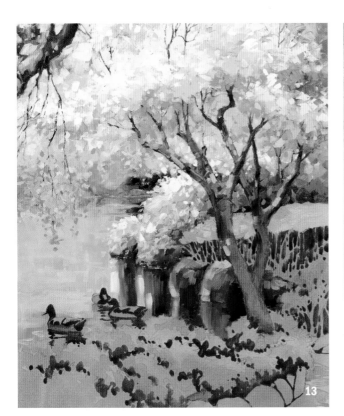

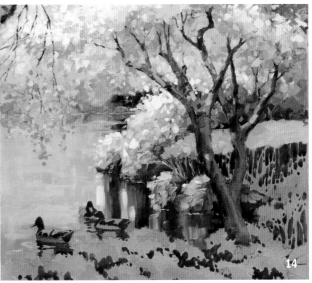

14. Tulips, Small Bushes and Reflections

Starting on the left side of the tree trunk, suggest some stems and leaves under the orange tulips and start fleshing out the small bushes, using Blue Grey, Leaf Green, mixes 11 and 13, plus touches of Lavender. Pull some of the same colors down into the water reflections.

13. Tulips, Bush and Water

Add Deep Yellow to the right side of the tulip mass and a few dabs into the shadow area. Add more color to the small bushes beneath.

Back to the water: work it around the ducks and the ducks' reflections and down to the top of the foreground flowers. Suggest some movement in the water around the ducks with a few swirly strokes of a lighter color.

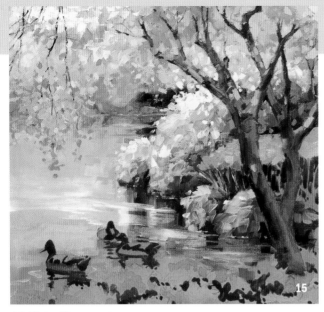

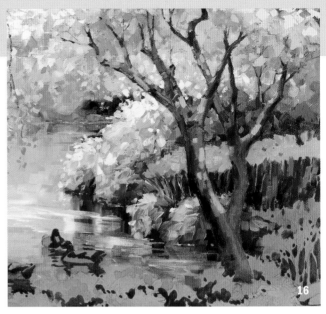

15. Water Movement

Some horizontal strokes of a light color, mix 8, combined with the vertical strokes already in place will give the water a wet, glassy appearance. It's important to remember not to use only horizontal brushstrokes when painting water—combining horizontal with vertical is the key! Using horizontal to slightly diagonal strokes, sweep from left to right, painting across the vertical reflections, both breaking them up and softening them for a more natural look.

16. Tulip Stems

Now go back over to the right side of the canvas and paint the darker values into the tulip stems using Mauve, Blue Grey, Green Grey and mix 7. Leave some orange-toned canvas showing for some of the stems.

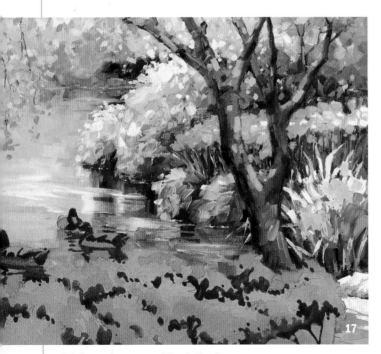

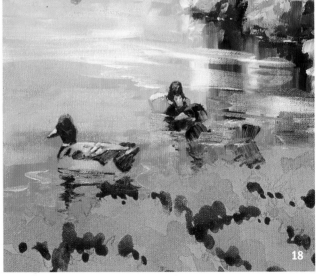

18. Ducks

Start painting the ducks with Cream, Yellow Grey, Rose Grey, Purple Lake, Lilac, Blue Grey and Cobalt Green.

17. Large Leaves and Rock Border

Add some light sun spots to the tops of the tulips on the far right. Paint some broad leaves up over the tulip stems. Paint a few spots of Deep Yellow in behind some of the stems. Continue painting the patch of foliage beneath the tulips with Lavender, Blue Grey, Ice Green, and mixes 8, 10 and 12.

 Add some very light strokes to the tops of those same leaves. Now paint the rock border and sunlit ground directly under, using mixes 1 and 4, Rose Grey and Purple Lake. Paint the ground around the cast shadow.

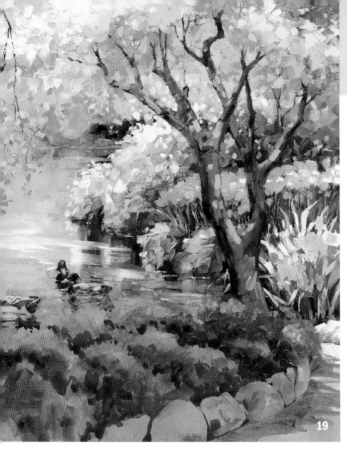

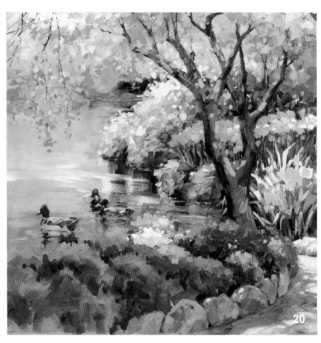

19. Flowers and Rock Border

Refine the duck on the right with mix 7 and Lavender on her wing, and with mix 1 on the top of her back.

Begin painting the mounds of flowers under the tree, the rock border and cast shadow. Use Orange Grey, Rose Grey, Lilac, Lavender and mix 7 for the rocks and shadow. Use Lavender, Blue Grey and mixes 5, 6 and 7 for the flowers and foliage.

20. Flowers and Rock Border

Continue the rock border and ground with the shadows cast upon it. Add sun spots on the tops of the rocks. Add Jaune Brillant, Light Magenta and mix 1 to the flowers.

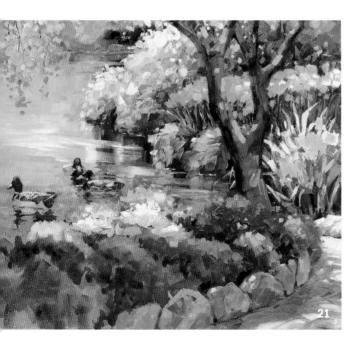

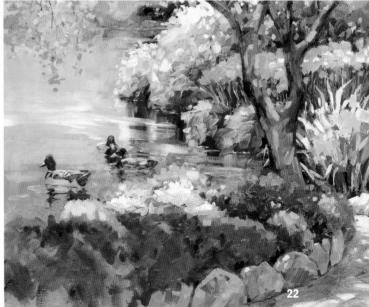

21. Dappled Light

As you carry on with the business of painting the mounds of red and purple flowers, pay close attention to how the light spots of color in the appropriate places works in concert with the cast shadows on the ground to create a dappled light effect.

22. Purple Flowers

Block in the shadow shapes of the purple mounds with mix 7.

Color Lesson #9: USE PAIRS OF COMPLEMENTS TO CREATE COLOR CONTRASTS

Here's another lesson on using complementary colors to create brilliant color contrasts (we looked at the purple-yellow complements in *Dutchman's Gold* on page 58). This time the painting utilizes two outstanding pairs of complements, with the red flowers, the pinks of the cherry tree and reddish-brown rocks surrounding the greens of the foliage and water—the red/green duo—being most prominent. The color swatches shown below are some of the reds and greens from the Color Mix Charts on page 114.

Next in importance is the orange/blue duo—notice how your eye bounces back and forth between the orange tulips and the blue

flowers, which pulls your attention even more to the ducks than it otherwise might. If you examine the painting you will find many warm/cool contrasts that may not be exact complements, but nevertheless provide color excitement.

Tip: If you study the color wheels on page 19, you will see that with every single complementary pair, one of the colors is warm and the other cool as defined by color definition #1, the "absolute" definition. For example, in the red/green complementary pair, red is on the warm side of the wheel and green is on the cool side. So there you have two contrasts: color *and* temperature.

GREENS

Cobalt Green

Mix 8

Prussian Green

Mix 9

Mix 13

Mix 10

Blue Grey

Ice Green

REDS

Mix 2

Mix 3

Lilac

Mix 7

Mix 6

Mix 5

Light Magenta

Mauve

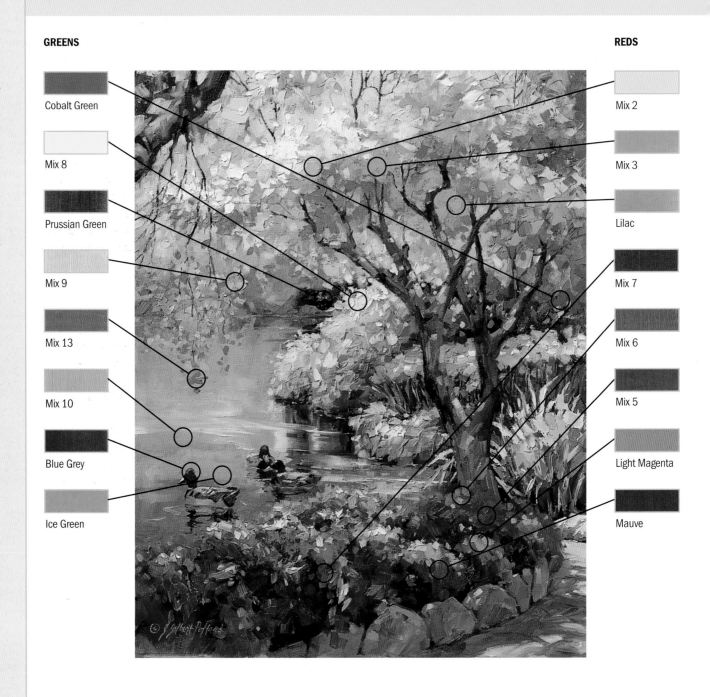

23. Purple Flowers

Add some definition to the purple flowers with suggestions of foliage and some lighter color—Lilac, Lavender and Cobalt Green—on the tops and some darker strokes in the shadowy recesses.

24. Flowers

Continue to add strokes of color and value as needed. Mix a little Lavender into some white and add just a few lighter spots of this onto the tops of the purple flower mounds, a few dabs of mix 2 on the red mounds, and mix 10 on a few of the leafy areas to suggest dappled light. These are small touches, but they do add to the feeling of sunlight.

25. Check Your Work

Now we're in the nitpicking stage! After stepping away from my painting for a while, I came back, studied it and decided to make a few tiny changes.

First I added a few more leaf shapes to the foliage under the tulips to give it more dappled light.

Then I added some horizontal light streaks in the water to the right of the ducks, taking care not to lose all of the vertical strokes that are already in place. Finally, I added a few more spiky leaves to the left of and behind the tree trunk to create more depth. Now I think we're done!

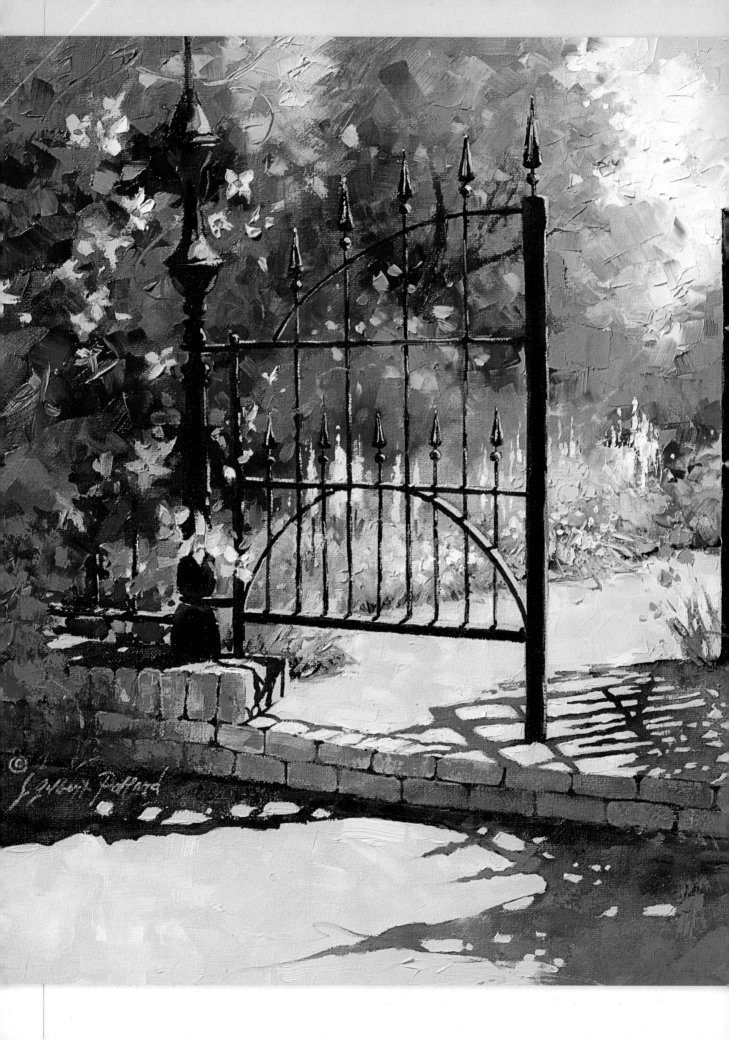

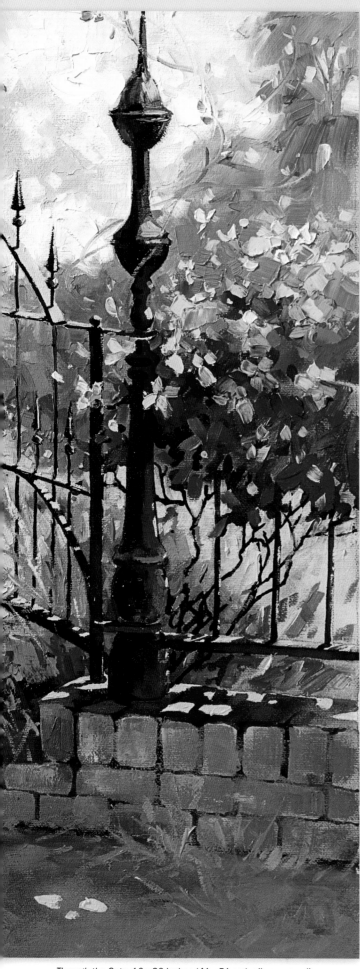

Through the Gate

As my husband and I were strolling through Victoria, British Columbia, we came upon a Victorian house with its lovely old iron gate, invitingly open, begging to be painted! I'm always on the lookout for subject matter and I carry a camera with me at all times. I do as much plein air painting as I can, but most of the time I paint in my studio from photos. Painting and photographing our favorite places allow us to bring them home with us. When I paint from my photos, my memories—visual, auditory, olfactory and emotional—become vivid. I'm there again. I get to re-live those moments of time spent in a magic place every time I paint. What joy—what a job!

Through the Gate, 16 x 20 inches (41 x 51 cm), oils over acrylic on canvas

ACRYLIC COLORS USED

Place the following acrylic colors on your palette as you need them. Thin to transparency as required in the instructions on the upcoming pages.

Nickel Azo Yellow
Transparent Pyrrole Orange
Dioxazine Purple
Anthraquinone Blue
Turquois (Phthalo)

Acrylic Mixes

Nickel Azo Yellow

Transparent Pyrrole Orange

Dioxazine Purple

Anthraquinone Blue

Turquois (Phthalo)

OIL COLORS USED

Place the following tube oil colors on your palette. Use a palette knife to create the mixes shown in the chart at right.

Titanium White
Lemon
Cream
Marigold
Yellow
Caramel
Yellow Grey
Deep Yellow
Jaune Brillant
Orange
Rose Grey
Light Magenta
Rose Violet
Mauve
Lilac
Lavender
Cerulean Blue
Ultramarine Blue
Prussian Blue
Blue Grey
Cobalt Green
Green Grey

Oil Color Mixes

Mix 1
Lemon + White +Marigold
1:1:a touch

Mix 2
Cream + Lilac + Marigold
5:2:a touch

Mix 3
Cream + Jaune Brillant + White
2:1:1

Mix 4
White + Light Magenta + Deep Yellow
5:1:a touch

Mix 5
Rose Violet + Lilac
1:1

Mix 6
Light Magenta + Lilac + White
2:1:1

Mix 7
Lilac + Rose Violet
5:1

Mix 8
Mauve + Jaune Brillant
2:1

Mix 9
White + Lavender + Orange
1:1:a speck

Mix 10
White + Lavender
1:a touch

Mix 11
Lavender + Mauve
3:1

Mix 12
Mauve + Lavender + Ultramarine Blue + Prussian Blue
4:3:1:1

Mix 13
White + Cerulean Blue
1:a speck

Mix 14
White + Cerulean Blue
1:a touch

Mix 15
White + Cerulean Blue
1:1

Mix 16
White + Cerulean Blue + Cobalt Green
1:1:1

Mix 17
Cream + Lavender + Cobalt Green + Marigold
2:2:1:a touch

Mix 18
Cream + Cobalt Green + Marigold
3:1:a touch

Mix 19
White + Cobalt Green + Marigold
1:touch:touch

Mix 20
Lemon + White + Cream + Cobalt Green
7:2:2:1

Mix 21
Deep Yellow + Cobalt Green
2:1

Mix 22
White + Lemon + Cerulean Blue
1:1:a speck

REFERENCE PHOTO, VALUE SKETCH AND DRAWING

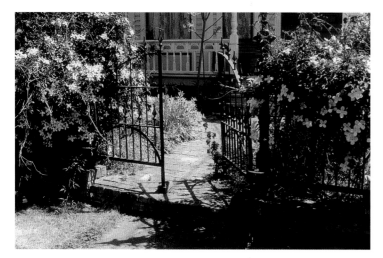

Reference Photo

Even though my reference photo shows a lovely Victorian house in the background, I didn't include the house in my painting. Victoria, B.C., is a city of gardens and this painting is all about an invitation to enter into a fabulous garden through an open gate.

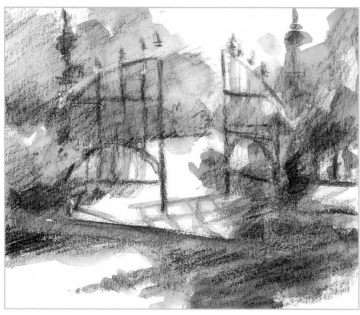

Value Sketch

Using a black water-soluble pencil, I first do a value sketch. I re-compose it a bit compared to the reference photo by adding more space at the top and shaving off some on both sides, creating a format more proportional to the shape of my canvas. I also re-design the composition by replacing the house with the suggestion of a garden. Note that precision is not necessary—or even desirable—in a value sketch. The *pattern* of light and dark is the whole point here.

 The new value composition pushes your eye up to the top part of the gate, rather than the shadow in the grass below the gate. In the photo, the top of the gate gets lost in the shadowed porch. The new sketch provides value contrast for that important area and helps lead the eye where I want it to go—which is *through* the gate and into the imagined garden!

Begin With the Drawing

Carefully draw or transfer the composition onto the canvas using a no. 2 pencil. Be precise with the delicate iron-work shapes of the gate. A traceable line drawing for this painting is available on page 141.

BEGIN WITH AN ACRYLIC UNDER-PAINTING

1. Gate and Fence

Using acrylic of a fluid consistency, begin by painting the vertical shapes of the fence and gate with Anthraquinone Blue.

2. Vertical Gate Posts

Paint the vertical gate posts with the same color. It is easier to paint a thin shape like a post by having the brush "aimed" at the edge from the inside of the shape rather than from the other direction.

3. Horizontal Bars, Finials and Posts

Using the same techniques, paint the horizontal and curved bars, the finials, and the large posts. On the left side posts, paint around the flower shapes. For the larger posts and finials use Dioxazine Purple and Turquois (Phthalo). Don't purposely mix them together but allow them to mix where they touch wet in wet. This adds color interest even at this early stage because some areas will be more purple and others, more turquoise. If you were to mix these two colors together the mixture would be the same color as Anthraquinone Blue, so you might prefer to continue using that color by itself, which would be fine.

4. Bricks and Grass

As you can see, the details of the gate need not be perfect!

Again using the same colors, paint the spaces between the bricks—also a broken series of brushstrokes at the bottom of the bricks to suggest little clumps of grass growing up along the edge of the bricks.

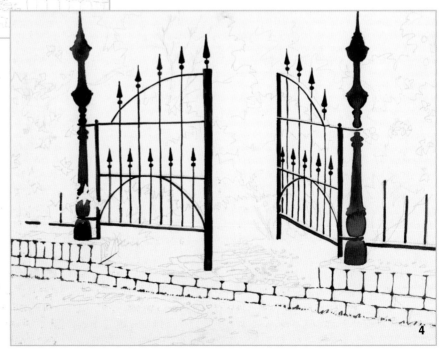

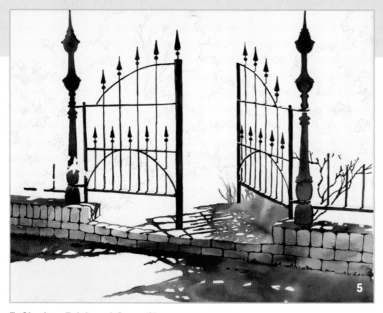

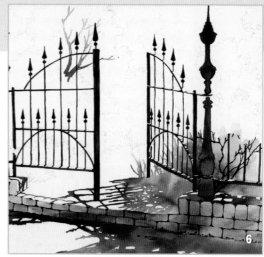

5. Shadow, Brick and Grass Shapes

Using the same dark color you used on the ironwork, paint some stems and twigs to support the flowering bush behind the far right post. Stop the twigs as they come up into the foliage area.

Now use transparent mixtures of fluid acrylics in Nickel Azo Yellow, Transparent Pyrrole Orange, Dioxazine Purple and Turquois (Phthalo), painting right over the previously painted ironwork and twigs. Alternating between warm and cool colors, allow the colors to run into each other within the boundaries of the shadow, brick and grass shapes. Treat these three types of shapes as one large shape. Don't mix the colors on your palette. Instead, brush in pure colors in appropriate dilutions and allow them to mix on the canvas.

6. Foliage, Tree Trunk and Branches

Continue those foliage colors up and to the right, again going right over the darker under-painting. Add the tree trunk and branches that are behind the left gate. Paint these branches from the top down starting with diluted Anthraquinone Blue and switching to Transparent Pyrrole Orange. If your blue runs down into your orange like mine did, the orange will become brown—not a problem.

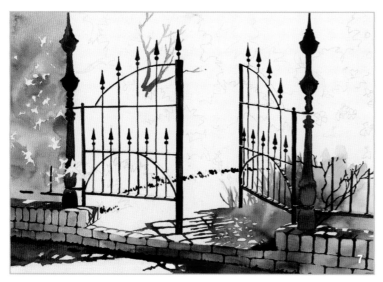

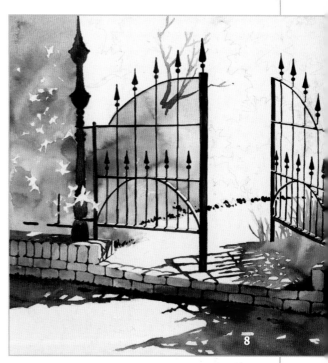

7. Background Washes

Paint some dark irregular marks to indicate the edge of the pathway. Using the same colors, though with less orange, continue with the transparent washes as in steps 5 and 6, extending up into the foliage area on the far left. Since it's easier to manage washes within "trapped shapes," paint one section at a time. (Note that the previously painted dark acrylic ironwork subdivides the canvas into segments. These segments are called trapped shapes.) Run your washes around a few flower shapes, allowing them to remain white. If you "lose" a flower shape, don't worry, you can always get it back later with white or pink paint.

8. Background Washes

Continue in the same manner into the large trapped shape of the gate on the left, painting the cool blues, lavenders and turquoises right over the bars and finials and middle curved bar until you get to where the edge of the path shows through the gate. At that point, switch to yellow to create an under-painting for those yellow flowers. Try to paint around the upper curved edge where the sun is hitting it. If you lose this light-struck area, don't worry. You can always paint it back in later with oil.

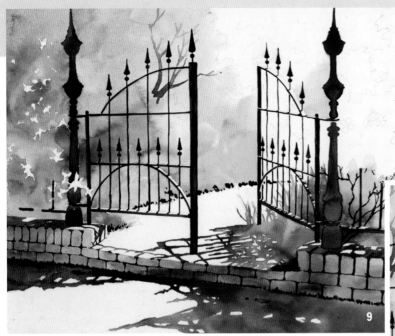

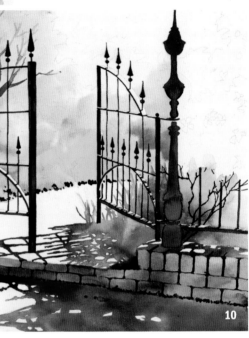

10. Transparent Washes

Extend the blue and yellow colors to behind the open gate on the right.

9. Transparent Washes

Now in steps 9, 10 and 11, paint the background that is still the original white canvas thinly with clear water. Into this wet surface, brush light dilutions of Dioxazine Purple, Anthraquinone Blue and Turquois (Phthalo) into the tree shapes, and Nickel Azo Yellow into the flower area. To achieve a continuous wash, just paint right over the ironwork—no need to paint around as long as your paint is *thinned to transparency*.

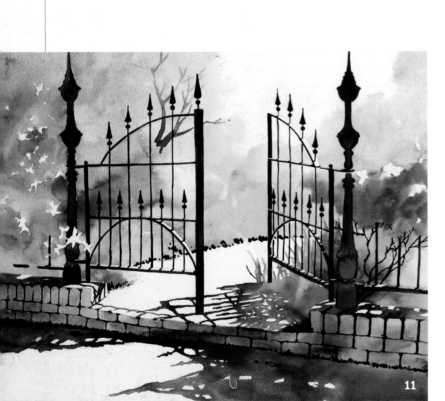

11. Transparent Washes

Continue working on the right side until the entire distant tree area plus the flowering vine is filled in. Leave a few flower shapes unpainted to the right of the large gate post.

12. Tree Trunk

Create depth by darkening the background where the tree trunk emerges from behind the foliage, using Dioxazine Purple and Anthraquinone Blue.

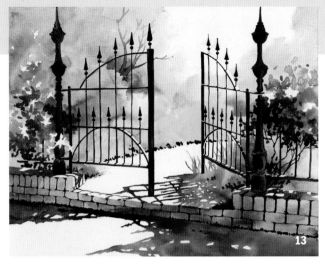

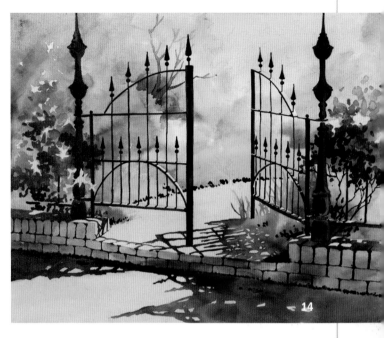

13. Dark Leaves

Add some dark brushstrokes of Anthraquinone Blue, suggesting dark inner leaves on the flowering vines on both sides of the gate.

14. Transparent Orange Wash

Thin down the Transparent Pyrrole Orange to a transparent consistency and apply quickly over all of the remaining white canvas. Allow this orange wash to overlap the previous washes to achieve a smooth look. You can soften the edges with clear water out into the blues/purples.

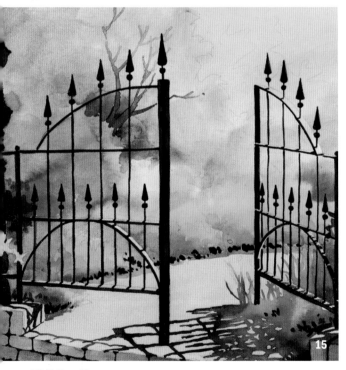

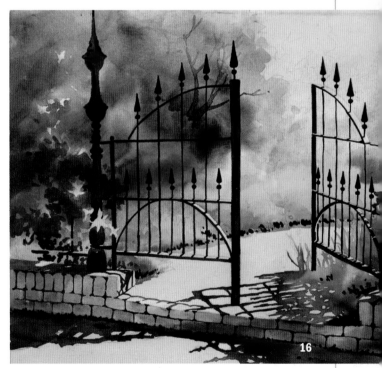

15. Yellow Flowers

Deepen the yellow at the base of the yellow flowers at the path's edge using Nickel Azo Yellow with very little dilution. This will model the flowers into mounded shapes.

16. Dark Foliage

Deepen the colors in the dark foliage on the left using Dioxazine Purple, Anthraquinone Blue, and Turquois (Phthalo).

This is the final step in the acrylic stages. We'll be painting with oils from here on.

PAINT IN OILS TO FINISH

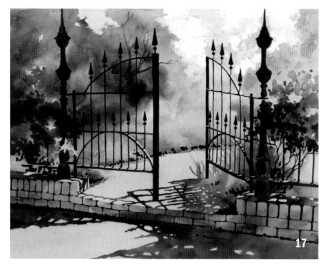

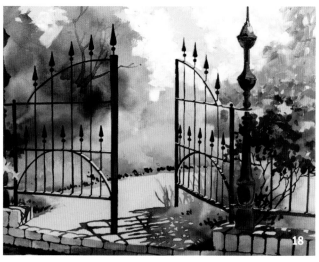

17. Sky Colors

Starting with the sky, "smear" appropriate colors—oil mixes 14, 15 and 16—over the acrylic under-painting. Allow bits of the under-painting to peek through. Remember, your objective is not to necessarily cover up all of the acrylic but to allow the two layers to form one image.

18. Sky and Large Finial

Carry on with the sky and distant tree line at right. Allow the boundary between tree and sky to have a soft edge quality. Add some of the lighter leaves of the vine to overlap the distant trees. Paint the large iron finial with Prussian Blue, Cerulean Blue, Rose Grey, and mixes 9 and 10, keeping in mind the light source which is off to the right and slightly behind the gate.

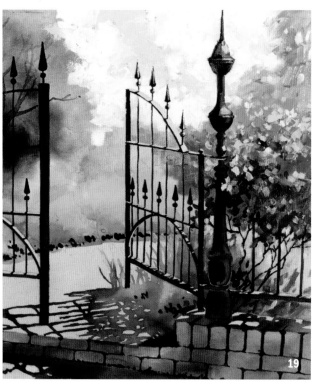

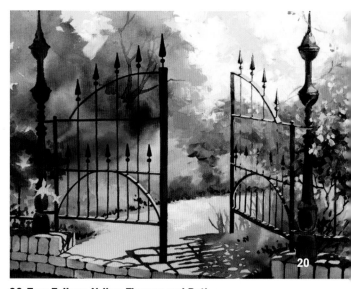

19. Finials and Flowers

Continue painting the blue sky and clouds and the finials that are sticking up into the sky. You will need to use both negative and positive painting to refine both. With Light Magenta and mixes 4, 5 and 6, paint the lighter flowers over the dark foliage. Paint the lower leafy edge of the flower mass and the grass below it that can be seen through the iron bars with Blue Grey, Green Grey, and mixes 18 and 20.

20. Tree Foliage, Yellow Flowers and Path

Using Lavender, Blue Grey, and mixes 2, 12 and 17, continue the tree foliage across towards the left gate. Try to paint that foliage background in between the iron bars. Swirl a few vines around the finial and add a few new spring leaves. Add some Caramel to the lower and under-side of the yellow flowers that edge the far side of the path. Further develop the yellow flowers and begin painting the dirt path. When painting the path, use "broken color" in two shades—Jaune Brillant and mix 3. Broken color will add interest to what otherwise could be a flat, unexciting space.

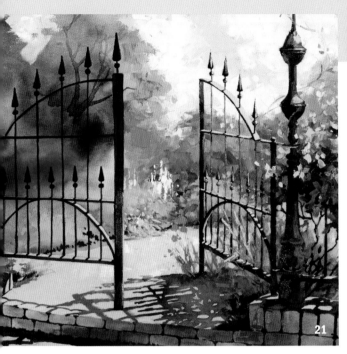

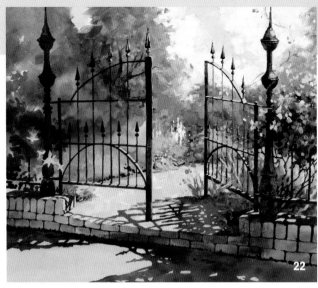

21. Gate, Flowers and Grasses

Continue to refine the gate spindles and finials and center post. Begin painting the lower portion of the center post by highlighting the light-struck side of which only a sliver can be seen. Paint the lower portion of the post on the right as well. For all of these areas, use Rose Grey, Prussian Blue, Cerulean Blue, and mixes 9 and 10.

Add some white stalk flowers behind the yellows, some brushstrokes of Orange to suggest flowers, a clump of grassy plant material, and some grass poking through the gate. Work some purple (mix 11) into the cast shadow under the open gate. Add some lighter green (mix 20) to the grass at the lower left path edge.

22. Path and Large Tree

Continue with the path, painting up to, around and inside the cast shadows to refine their shapes.

Paint the large tree and the bushes in front of it using Lavender, Blue Grey, and mixes 2, 12 and 17.

Add the light-struck sides to the finials on the left gate and center post towards the top with mix 13.

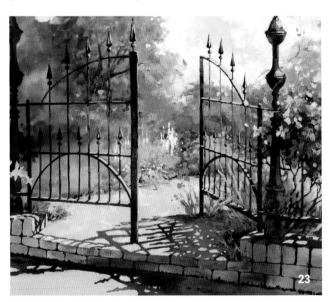

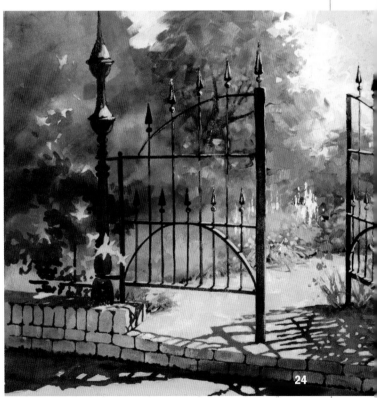

23. Pale Green Plant, Grass and Bricks

Extend the pale green grassy plant to be seen through the left gate. Add some lighter brush strokes to the foliage under the tree.

Add some blades of grass at the bottom of the open gate and begin working on the bricks in that area. Apply Rose Grey and touches of mix 12 to the faces of the bricks, and Jaune Brillant to the sun spots on the tops of the bricks between the cast shadows.

24. Large Finial on Left Side of Gate

Start painting the large finial on the far left. The shaded left side of the finial is painted with Prussian Blue and the sunlit parts on the right side are painted with Rose Grey and mixes 9 and 10.

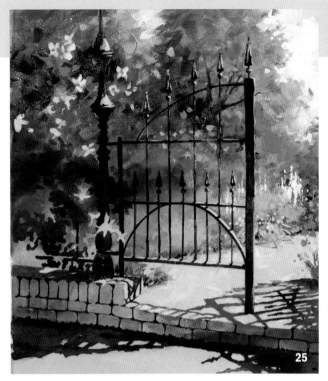

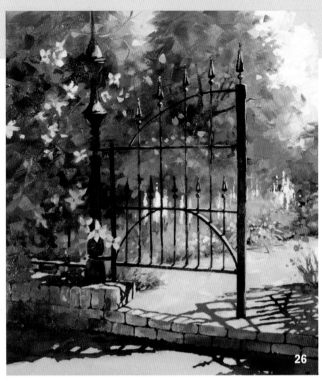

25. Flowers and Leaves

Paint flowers and foliage around the left-side finial and boldly scrape a swirling vine into the air around it. Flick in a few lighter leaves above the finials and behind the gate with mix 20.

26. Flowers, Post, Bricks and Shadow

Continue on down with the flowers, foliage, post, bricks and shadow. With Light Magenta, and mixes 4 and 5 (for the centers) and 6, add more flowers. With Cerulean Blue, Blue Grey, Green Grey, mixes 11, 12 and 21, create broken color around the flowers to suggest foliage. Use Prussian Blue where needed to reclaim any of the iron post that might have gotten lost. Merge the foliage into the brick area rather than creating a separation between the two subjects. This is an area that should be rather loosely defined. Bring some of the white stalks of flowers further left to be seen behind the gate.

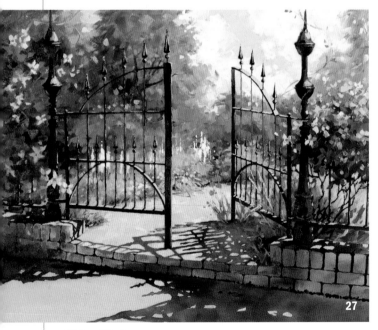

27. Iron Work

Finish painting the iron work. Use Prussian Blue to re-establish iron bars and small finials as needed. Then add touches of sunlight hitting on the right side with mixes 9 and 10.

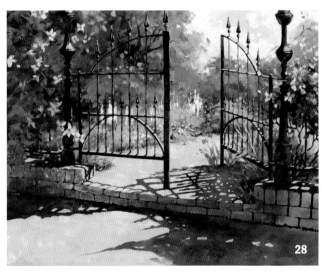

28. Lower-Level Path

Paint the lower level of the ground in both sunlight and shadow, using broken color—Cream, Jaune Brillant and mix 3—as you did on the upper level.

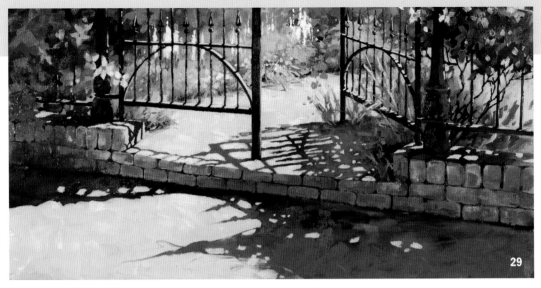

29

29. Bricks and Cast Shadow

Loosely add color and texture to the bricks, brushing on Rose Grey, Lilac, Blue Grey, mixes 7, 8 and 11 and even a few touches of Orange here and there. Allow the dark acrylic that shows the separations between the bricks to show, rather than painting the lines with oil. Add some lost edges by smudging over those lines in just a few places. Add more sunlight shapes in the cast shadow.

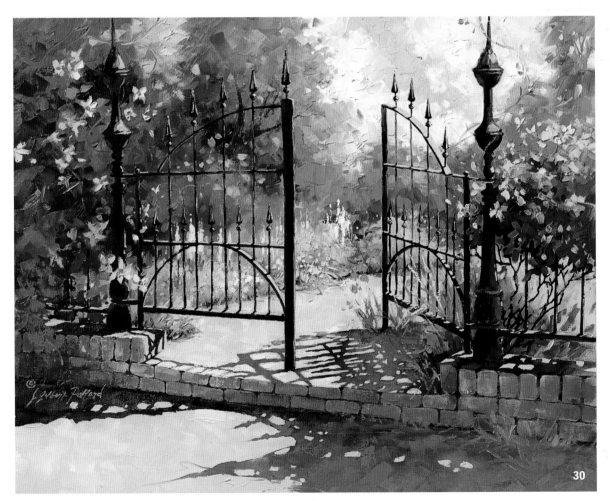

30

30. Check Your Work

Step back from your painting and see if it needs any adjustments. I think the lower right edge of the brick wall is a little too strong and attracts too much attention, so I will "plant" some sprigs of grass along where the brick meets the ground to soften that strong diagonal shape and bring the eye back into the painting. Amazing how such a small change makes all the difference!

Color Lesson #10: THE EMOTIONAL IMPACT OF COLOR

Color invokes such strong emotional response that a book about color would be incomplete without talking about *emotional impact*.

The conundrum is this: Every painting you undertake has subject matter that has "spoken" to you somehow. We all have an elusive mental and emotional picture of what we would like to express in paint. Yet, all a painter has at her disposal with which to create her "dreamscape" is a flat canvas and a few tubes of paint. The fact is, you must learn the nuts and bolts of painting—your skills must "catch up" with your vision before you can put on canvas what you see in your mind's eye.

One essential skill is that of analysis. Let's analyze the emotional impact of this painting created by subject and color.

While this painting—as is true with every painting—has multiple features that must be evaluated, the overriding feature of this painting is the subject matter and how it in itself evokes feelings:

- The wrought iron gate is strong with sharply pointed finials, meant to keep people out—yet it is open and inviting, making you feel welcome, even privileged, important.

- The open gate, path and flowers beyond are suggestive of hope and expectation.

- The sunlight and flowers tell us it's a warm and comfortable day—a happy day.

The second most obvious element used is color and color temperature. Cool colors predominate here, yet the painting does not look cold because the cool colors are balanced by the warm colors of the sunlit path and the yellow, pink and red-orange flowers. The sunlit parts of the path are painted with warm hues of pale peach and yellow, which are "happier" colors than the earth tones that you might ordinarily associate with a dirt path. The shadow areas are painted with cool tones of blue, mauve, lilac and purple, adding a feeling of mystery and romance. Still, there is some neutralized, more "earthy" color as well, just enough to lend a touch of reality. Without that balance, the painting might tip over the edge into saccharine sweetness.

A tip: as you paint cool colors, always add a bit of warm color next to them and vice versa. The resulting contrast in color temperatures helps create brilliant colors and a lively, exciting painting.

So, I had several emotions I wanted to express. How well do the nuts and bolts—subject, drawing and composition, use of color and value, brushstrokes and technique—support these ideas? There's usually more to a painting than just a pretty picture!

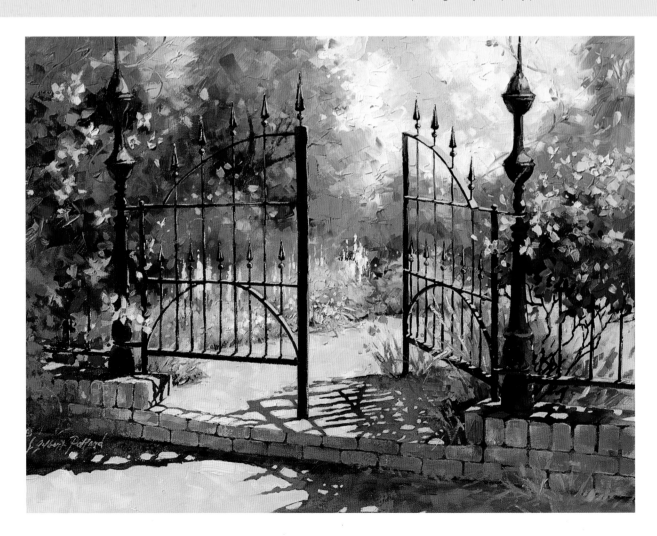

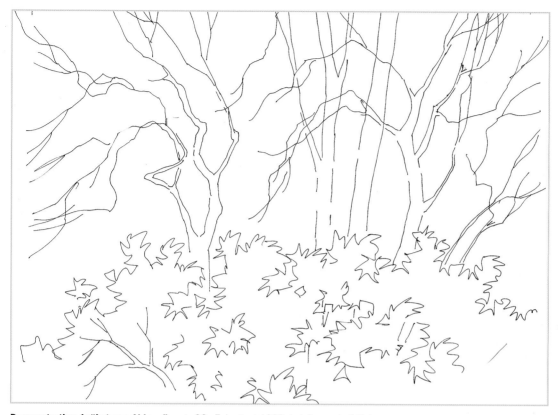

Demonstration 1: "Autumn Ablaze," page 28. Enlarge at 130% to bring up to full size.

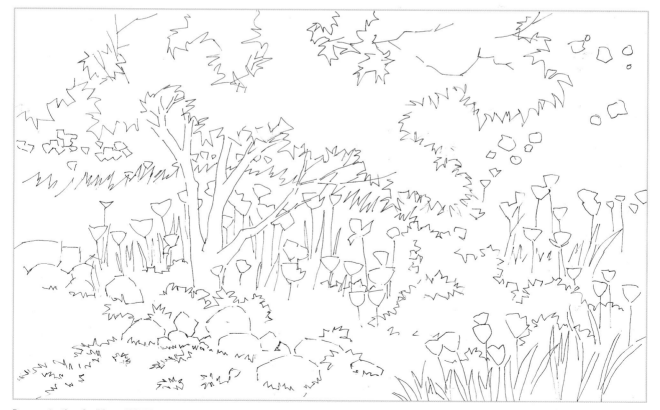

Demonstration 2: "Gone Wild," page 38. Enlarge at 145% to bring up to full size.

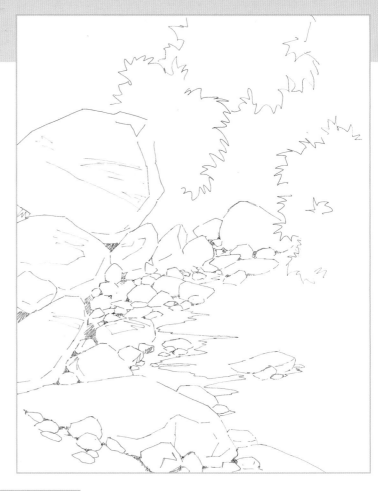

Demonstration 3: "Dutchman's Gold," page 48. Enlarge at 208% to bring up to full size.

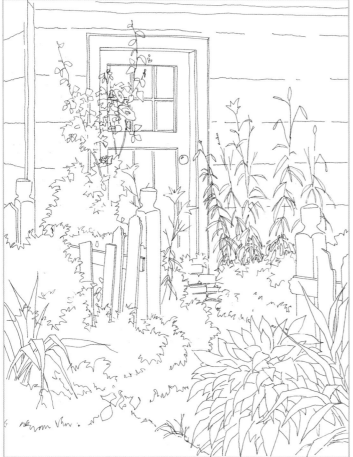

Demonstration 4: "The Red Shed," page 60. Enlarge at 208% to bring up to full size.

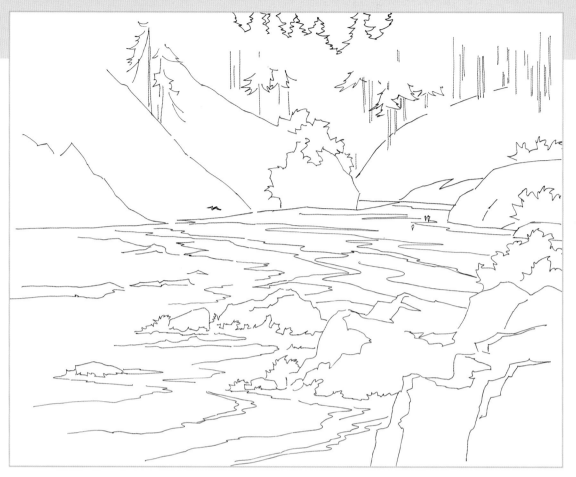

Demonstration 5: "Ecola Cove," page 70. Enlarge at 169% to bring up to full size.

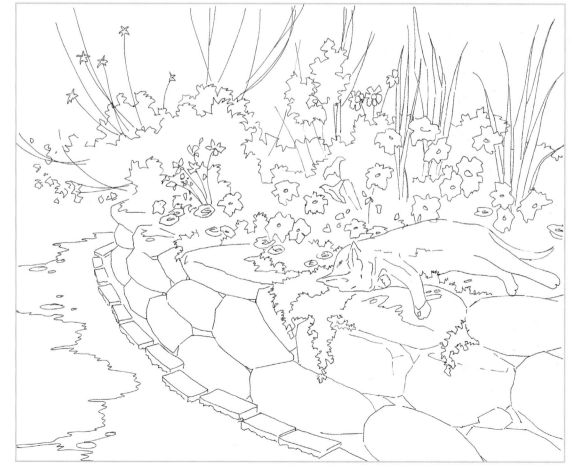

Demonstration 6: "La Siesta del Gato," page 80. Enlarge at 169% to bring up to full size.

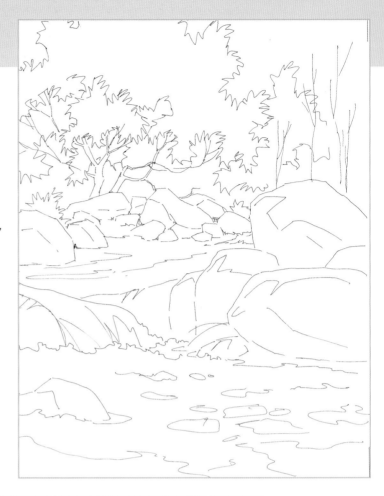

Demonstration 7:
"Twilight on the Creek," page 90. Enlarge at 208% to bring up to full size.

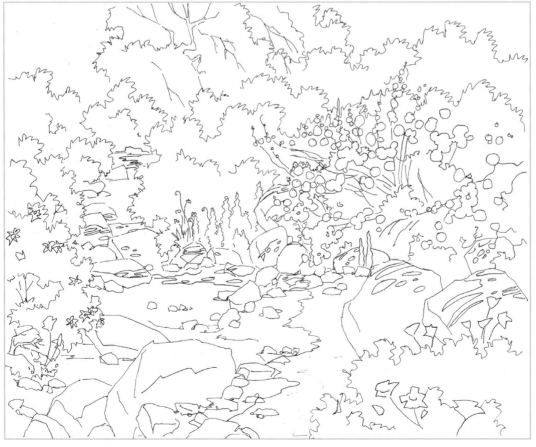

Demonstration 8:
"Sonoran Spring,"
page 102. Enlarge at 175% to bring up to full size.

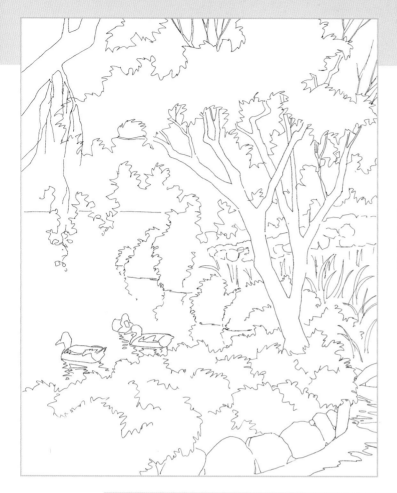

Demonstration 9: "Butchart Gardens Gem," page 112.
Enlarge at 208% to bring up to full size.

Demonstration 10: "Through the Gate," page 124.
Enlarge at 167% to bring up to full size.

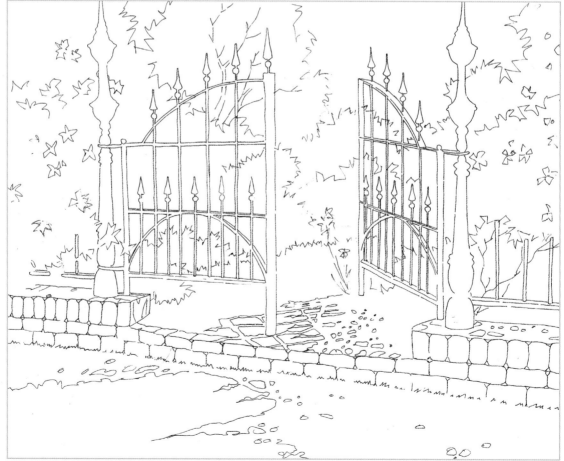

RESOURCES

U.S. RETAILERS

Acrylic Paints

Golden Artist Colors, Inc.
188 Bell Road
New Berlin, NY 13411
Ph. 1-800-959-6543
goldenart@goldenpaints.com
www.goldenpaints.com

Oil Paints

Holbein Artist's and
Designer's Materials
usa@holbeinusa.com
www.holbeinhk.com

Winsor & Newton
ColArt Americas
11 Constitution Ave.
Piscataway, NJ 08855
Ph. (732) 562-0770
www.winsornewton.com

Brushes

Winsor & Newton
(see address above)

Connoisseur
www.connoisseurart.com

Royal & Langnickel
www.royalbrush.com

Miscellaneous Supplies

Blair Art Products
4310 Cranwood Parkway
Warrensville Heights, OH 44128
Ph. 1-866-833-7797
www.blairartproducts.com

Masterson Art Products, Inc.
P.O. Box 11301
Phoenix, AZ 85017
Ph. 800-965-2675
www.mastersonart.com

Mona Lisa Products
Houston Art, Inc.
10770 Moss Ridge Rd.
Houston, TX 77043
www.monalisaarts.com

Silicoil Brush Cleaning Tank
The Lion Company
22 Carriage Drive
Lexington, MA 02420
zaurie@thelioncompany.com

Tube Wringer
Gill Mechanical Co.
Eugene, OR
Ph. (541) 686-1606
www.tubewringer.com

CANADIAN RETAILERS

Crafts Canada
120 North Archibald St.
Thunder Bay, ON P7C 3X8
Tel: 888-482-5978
www.craftscanada.ca

Folk Art Enterprises
P.O. Box 1088
Ridgetown, ON, N0P 2C0
Tel: 800-265-9434

MacPherson Arts & Crafts
91 Queen St. E., P.O. Box 1810
St. Mary's, ON, N4X 1C2
Tel: 800-238-6663
www.macphersoncrafts.com

INDEX

The Best in Painting Instruction and Inspiration is from North Light Books!

Achieving Depth & Distance: Painting Landscapes in Oils unlocks the secrets to beautiful, realistic landscapes you can step right into! Popular artist and teacher Kitty Gorrell shows you how to create great depth and a sense of space in your paintings. With ten step-by-step demonstrations that take you from start to finish, you'll learn how to paint near, middle and far distances in many favorite landscape settings—woodlands, lakes and valleys, fields and mountains—even an ocean view and a snowy winter evening in the backwoods. Watch your landscapes come alive with color, value and detail, the basic elements that build the feeling of depth and distance in any painting. ISBN-13: 978-1-60061-024-0; ISBN-10: 1-60061-024-2; paperback, 144 pages, #Z1308

If you are always looking to improve the way you visualize your art, artist Bob Rohm shows you how in *The Painterly Approach: An Artist's Guide to Seeing, Painting and Expressing.* Here you will discover what the "painterly approach" is and how to define an object by planes of color and value rather than by line. You'll learn how to see shapes and values and the relationships between them, how to focus on abstract patterns rather than on actual objects, and how to provoke emotional responses no matter what your subject. Finally, a step-by-step approach to painting, using *alla prima* and *en plein air* demonstrations, show how to apply the painterly approach from preliminary drawing to finished painting. ISBN-13: 978-1-58180-998-5; ISBN-10: 1-58180-998-0; hardcover, 144 pages, #Z0984

Nothing enhances a landscape like the play of light! Now you can capture its rich, illusive properties in your own paintings by following along with beloved artist Dorothy Dent. *Painting Landscapes Filled with Light* shows you step-by-step how to use light direction and color tonal values to create light-filled scenes in different seasons, weather conditions and times of day. Ten complete demonstrations in both oils and acrylics teach you how to capture spectacular sunsets, dramatic light and shadow on snow, sun-sparkled water, the colorful glow of summer flowers, and so much more. Hundreds of full-color photos, helpful diagrams and insightful commentary by Dorothy ensure your painting success! ISBN-13: 978-1-58180-736-3; ISBN-10: 1-58180-736-8; paperback, 144 pages, #33412

Painting water effects can be a challenge for any artist! *Robert Warren's Guide to Painting Water Scenes* answers that challenge and shows how to create water in all its forms and in all seasons. Renowned artist and nationally televised teacher Robert Warren shares his own special secrets for capturing ocean waves, waterfalls, quiet reflective lakes, woodland streams, whitewater cascades and more in 12 easy-to-follow painting demonstrations that begin with an acrylic underpainting and finish with oils. If you are taking your first "plunge" or if you're a seasoned pro, painting water will no longer be a mystery! ISBN-13: 978-1-58180-851-3; ISBN-10: 1-58180-851-8; paperback, 128 pages, #Z0054